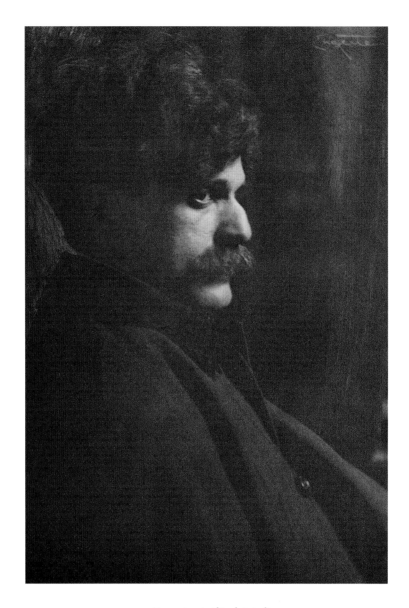

FRANK EUGENE ■ *Portrait of Alfred Stieglitz,* 1900

STIEGLITZ AND THE
PHOTO-SECESSION
1902

TEXT BY WILLIAM INNES HOMER

EDITED BY CATHERINE JOHNSON

VIKING STUDIO

Editor: Christopher Sweet
Editorial Assistant: Laura Baron
Managing Editor: Tory Klose
Production Editor: Kate Griggs
Designer: Carla Bolte

VIKING STUDIO

Published by the Penguin Group

Penguin Putnam Inc., 375 Hudson Street, New York, New York 10014, U.S.A.

Penguin Books Ltd, 80 Strand, London WC2R 0RL, England

Penguin Books Australia Ltd, 250 Camberwell Road, Camberwell, Victoria 3124, Australia

Penguin Books Canada Ltd, 10 Alcorn Avenue, Toronto, Ontario, Canada M4V 3B2

Penguin Books (N.Z.) Ltd, Cnr Rosedale and Airborne Roads, Albany, Auckland, New Zealand

Penguin Books Ltd, Registered Offices:
Harmondsworth, Middlesex, England

First published in 2002 by Viking Studio,
a member of Penguin Putnam Inc.

10 9 8 7 6 5 4 3 2 1

BIOGRAPHIES OF THE PHOTOGRAPHERS PREPARED BY LAURA BARON

CIP data available

ISBN 0-670-03038-4

This book is printed on acid-free paper. ∞

Printed in China
Set in Centaur with Copperplate Gothic

Author's Acknowledgments

I WOULD LIKE TO EXPRESS MY INDEBTEDNESS, ABOVE ALL, TO CATHERINE JOHNSON, my partner in a most interesting and rewarding enterprise. Together she and I confronted any number of challenges and, at times, frustrations. But we both persevered, and the final product was well worth the effort that we put into it.

I would also like to thank Christopher Sweet and Laura Baron, both of Viking Studio: Christopher for his unflagging confidence in the project and Laura for her thoughtful biographies of the photographers who participated in the 1902 show.

I have been engaged in Photo-Secession studies since the 1970s. From that decade to the present I have benefited from the help of many individuals, chief among whom are the following: Peter Bunnell, Martha Chahroudi, Marianne Fulton, David Haberstich, Susan Kismaric, Weston Naef, and David Travis. Sarah Greenough has been particularly cooperative in making available to me the "Key Set" of Stieglitz photographs at the National Gallery of Art.

Finally, I want to thank my wife, Christine, for reading the manuscript of my text and making many valuable editorial suggestions.

—*William Innes Homer*

Editor's Acknowledgments

I WOULD ESPECIALLY LIKE TO THANK REBECCA JOHNSON MELVIN, MY SISTER, who kindly introduced me to Professor William Innes Homer. His knowledge of and passion for the history of photography is beyond compare; I was extraordinarily lucky to have worked on this project with such a stellar and approachable scholar.

■ I also owe a very special thanks to Norman Parkinson, a photographer I had the good fortune to meet and work with for six years. I know he would have been very appreciative of this book.

■ And, of course, my parents, who instilled in me a love for history and photography.

■ This book was made possible with the support and enthusiasm of the following people: Christopher Sweet, Laura Baron, and Carla Bolte at Viking Studio; Aldon James, president of the National Arts Club, for his inspiration; and the entire National Arts Club Photography Committee: Lucy Bowditch, Jason deMontmorency, Elaine Ellman, Jeffrey Jay Foxx, Daile Kaplan, Linn Sage, Bruce and Suzanne Poli, Robert Schrijver, Philip Reeser, Robert Sharpe, Gary Scharfman, Jennifer Gyr, Jay and Rose Deutsch, Maria Chatzinakis, and Erica Levin. Also, David Redding for his diligent help in tracking down a photograph of West Thirty-fourth Street, circa 1900, the original address of the National Arts Club.

For their help in researching the images, I would like to thank the following generous and knowledgeable professionals: Janice Madhu and Barbara Puorro Galasso at the George Eastman House, Rochester, New York; Samantha Johnson and Pam Roberts at the Royal Photographic Society, Bath, England; Mary Doherty at the Metropolitan Museum of Art, New York; Mikki Carpenter at the Museum of Modern Art, New York; Denise Gose, Leslie Calmes, and especially Marcia Tiede at the Center for Creative Photography, the University of Arizona, Tucson; Tiffany Calvert and Nora Riccio at the Art Institute of Chicago; and Anne Havinga and Erica Hirschler at the Museum of Fine Arts, Boston.

Also, April Watson and Peter Huestis at the National Gallery of Art, Washington, D.C.; Verna P. Curtis at the Library of Congress, Washington, D.C.; Jean Martin at the Old Depot Museum, Selma, Alabama; Mikka Gee Conway, Beth Guynn, and Wim DeWit at the J. Paul Getty Museum, Los Angeles; Peter Bunnell at the Art Museum, Princeton University; Stacy Bemento at the Philadelphia Museum of Art; Christian Peterson and DeAnn Dankowski at the Minneapolis Museum of Art; Darian Daries at the University of California Library, Special Collections; and Helen Gee of New York City.

—*Catherine Johnson*

Editor's Note

IN 1899, ALFRED STIEGLITZ WROTE, "IN THE PHOTOGRAPHIC WORLD TODAY there are recognized three classes of photographers—the ignorant, the purely technical, and the artistic." He added, "There are many private art collections to-day that number among their pictures original photographs that have been purchased because of their real artistic merit. The significance of this will be the more marked when the prices paid for some of these are considered, it being not an unusual thing to hear of a single photograph having been sold for upward of one hundred dollars. Of the permanent merit of these pictures posterity must be the judge, as is the case with every production in any branch of art designed to endure beyond the period of a generation."

Three years later, Stieglitz organized an exhibition of a group of photographers he respected to further champion his cause for the public acceptance of photography as art. During a blinding blizzard on the evening of March 5, 1902, the National Arts Club in New York City opened its doors to this exhibition of photographs by Stieglitz and his fellow Photo-Secessionists.

Although we know from documentation in the journal *Camera Notes* that Stieglitz made a brief speech to the attendees on the opening night, there is unfortunately no verbatim record of his lecture. "The talk was unprepared and informal, the speaker beginning with a definition of 'Photo-Secession,' outlining the growth of pictorial photography the world over, whose culmination was the 'Secession,'" reported *Camera Notes*. "The rooms of the Arts Club were visited by many more people than had attended any other exhibition within

this club. The public interest and the great success of this exhibition . . . was . . . acknowledged by many who had seen all the best photographic exhibitions of recent years here and abroad to have been the choicest collection ever assembled under one roof."

The National Arts Club Photography Committee wishes to honor Stieglitz and commemorate this historically significant photographic event of 1902. So, here in time for the centennial, this book is a tribute to Alfred Stieglitz and the Secessionists for their successful pioneering campaign to introduce Americans to the best in the art of photography. The National Arts Club is proud to have hosted this exhibition when there were no galleries showing photography in New York, and there was not a single photograph by any of these artists in an American art museum collection.

One hundred years ago, Stieglitz expressed a sentiment that is still relevant to all of the arts today. "The point is, what you have to say and how to say it. The originality of a work of art refers to the originality of the thing expressed and the way it is expressed, whether it be in poetry, photography, or painting."

—*Catherine Johnson*
Chair, Photography Committee
National Arts Club

ALL ROYALTIES FROM THIS PUBLICATION WILL BE DONATED TO THE NATIONAL ARTS CLUB.

The Photo-Secession Show of 1902 at the National Arts Club

WILLIAM INNES HOMER

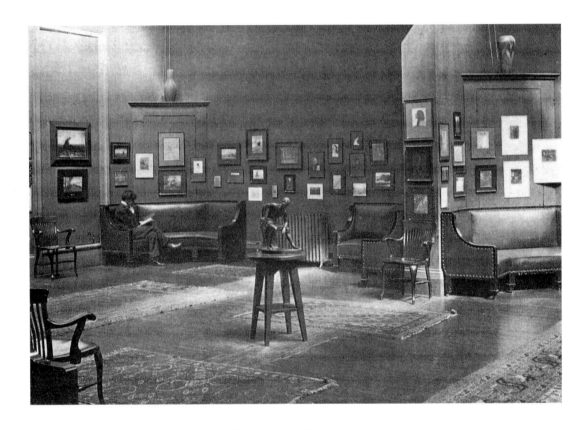

Photo-Secession exhibition at the National Arts Club, 1902. From *Camera Notes.* Photographer unknown.

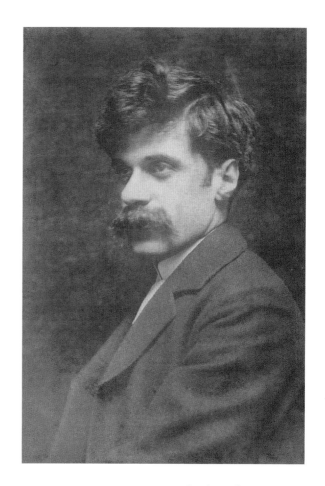

FRANK S. HERMANN ■ *Alfred Stieglitz,* circa 1894.

Private collection.

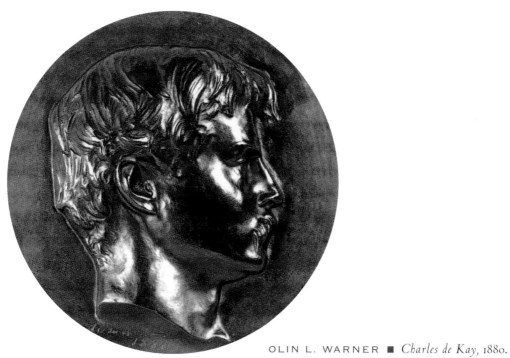

OLIN L. WARNER ■ *Charles de Kay,* 1880.

Bronze, 8¾ inches diameter, The Century Association, New York City.

and influential body of pictorial photographers ever to flourish in the United States, was held at New York's National Arts Club. Organized mainly by photographer and impresario Alfred Stieglitz at the invitation of the club's managing director, Charles de Kay, this show was a testament to Stieglitz's leadership in American pictorial photography. It also defined the National Arts Club as a supporter of a progressive cause in the arts and as a champion of a then underappreciated medium—photography. Today photography is accepted as one of the fine arts, but it was not always so. Years of struggle in the late nineteenth and early twentieth centuries were necessary before critics and audiences were won over. Virtually every nation in the Western world hosted advocates of the cause, and in our country, Stieglitz vanquished his adversaries and became the acknowledged leader.

The show, titled American Pictorial Photography Arranged by the Photo-Secession, was held from March 5 through 24 (although the catalogue indicates a March 22 closing). Hung at the National Arts Club's original home at 37–39 West Thirty-fourth Street, the exhibition represented a collaboration between an ambitious young institution, the club, and a nascent photographic organization, the Photo-Secession. The latter group was just coming into existence and was embodied chiefly in the person of Alfred Stieglitz. Indeed, the club's pointed interest in pictorial photography helped Stieglitz give birth to the Photo-Secession.

Alfred Stieglitz's early life is bound up with the growth of amateur photography. It was primarily the amateurs, not the professionals, who laid the groundwork for artistic progress in the medium. Perhaps because they had ample spare time and assured sources of income, these photographers could focus on making photography an art and cared little whether their prints sold. Amateurs were found throughout Europe and America, and at the turn of the century the idea of art, or pictorial, photography enjoyed tremendous international popularity. Journals and photographic salons flourished.

ALFRED STIEGLITZ ■ *Self-Portrait*, 1886.

Platinum, National Gallery of Art, Washington, D.C.,
Alfred Stieglitz Collection

■ Born in Hoboken, New Jersey, in 1864 and raised in New York City, Stieglitz entered the world of amateur photography as a young man, making his first photographs while he was a student of engineering in Berlin (1881–90). He took to the medium like the proverbial duck to water. During his stay in Germany, and on visits to Austria and Italy, he produced hundreds of expert photographs: portraits, landscapes, and scenes of the everyday life around him. He was in every sense an amateur, turning his back on commercial gain and allying himself with individuals and groups that had similar aims. His immense talent as a photographer brought him quick recognition within the international community of amateur photographers.

Alfred Stieglitz was also a born leader and proselytizer. His cause was to promote high aesthetic quality in the photograph, something he believed could be accomplished within the amateur community. He devoted himself to this ideal upon his return to the United States in 1890, waging a public battle for excellence in photography that continued almost to the end of the First World War. Stieglitz led by the personal example of his own work, but he also operated within groups and organizations. At first he utilized existing channels, including the magazine *American Amateur Photographer*, where he served as coeditor (1893–96). Then he moved on to the Camera Club of New York, where he became vice president and editor of the club's new journal, *Camera Notes* (1897–1902).

ALFRED STIEGLITZ ■ *Weary*, 1890. Gelatin silver, National Gallery of Art, Washington, D.C., Alfred Stieglitz Collection

ALFRED STIEGLITZ ■ *The Terminal*, 1893. Carbon, National Gallery of Art, Washington, D.C., Alfred Stieglitz Collection

■ The Camera Club became Stieglitz's base of operations around the turn of the century. Within its membership he found sympathetic allies, such as Joseph Keiley, Dallett Fuguet, and John Francis Strauss. The rank-and-file members of the club, however, were not convinced of Stieglitz's views. He tried to persuade his listeners and readers that the photograph could indeed be art, an aesthetic object that should, above all, express the individuality of its maker. The means of doing this, according to Stieglitz, were unimportant. The photographer could use dark, moody lighting with indistinct forms or create misty, soft-focus effects. Any technique was acceptable, even scratching the negative or retouching the print. Stieglitz himself, however, only rarely adopted these methods, which resembled painting: he preferred a sharp-focus, straight approach, as opposed to what has been called the painterly photograph.

Camera Notes was Stieglitz's first consistent platform for his photographic crusade. As editor of this magazine he placed his stamp on it throughout, offering clues to the positions he would later express in the first Photo-Secession show. In Camera Notes he created a serious journal that spoke through himself and his chosen authors about the merits of enlightened pictorial photography. Moreover, he reproduced, in fine photogravure prints, those photographs that he thought were worthy of attention, European as well as American examples. All this was designed to raise the status of photography, particularly in the United States. A note of patriotism or cultural nationalism is reflected in these efforts, a sense that America must lift itself by its own photographic bootstraps.

Cover, *Camera Notes.*

Lee Gallery, Winchester, Massachusetts.

Cover, *Camera Work.* Private collection.

■ Stieglitz had to struggle to champion the kind of pictorial photography he believed in, and accordingly *Camera Notes* encountered resistance from the Camera Club's traditionalists (in 1902 the magazine was taken over by that faction and it soon failed). In light of events like this, Stieglitz must have grown weary of trying to reform the established photographic world from within. Yet he continued to search for opportunities to advance his agenda through publications and exhibition programming. Stieglitz started the luxurious magazine *Camera Work* in 1902 (the first issue was dated 1903). It generated much-needed publicity for his cause through the printed word and reproduced select images in high-quality photogravure. His exhibition agenda, which included his hope for an annual American photographic salon modeled after those found in Europe, was not as easily fulfilled.

■ Stieglitz was not alone in this quest for an exhibition program that favored the best in pictorial photography. Others in the United States and Europe had tried to devise solutions

with varying degrees of success. Through the salons of London's Linked Ring (1893–1909), a breakaway group from the Photographic Society of Great Britain, the British had set an example on the international scene, followed by similar photographic salons and special exhibitions in Paris, Hamburg, Brussels, Vienna, and The Hague. In addition, photographs finally had won acceptance by some of the larger international expositions, including the International Exhibition in Glasgow in 1901.

■ In spite of this progressive activity abroad, the achievements of the leading American pictorialists were not suitably showcased, collectively or on a continuing annual basis, such as in a salon based in New York. In the meantime, however, officials of the Pennsylvania Academy of the Fine Arts asked the Photographic Society of Philadelphia if it would join with them to present a series of photographic salons of international scope each year, beginning in 1898. Stieglitz had hoped to sponsor such an annual salon in New York, but had

Catalogue cover,
Philadelphia Photographic Salon, 1898.

Private collection.

not been able to manage it, so he threw his ideological and political support behind the Philadelphia group. In fact, he was a member of the first jury. These salons came into being mainly through the efforts of four Philadelphia photographers, all of them friendly with Stieglitz: Robert Redfield, John G. Bullock, Edmund Stirling, and George Vaux, Jr. For the first three years Stieglitz was pleased by this solution to the American salon problem, but conservative forces within the Photographic Society ultimately challenged and undermined the salon's elitist emphasis on aesthetic quality. The salon lost Stieglitz's support and, wracked by internal dissension, did not survive beyond 1901.

Still another American salon that enjoyed Stieglitz's assistance was the Chicago Photographic Salon, arranged by one of his trusted colleagues, the Chicago-based photographer William B. Dyer. This was the first presentation to feature a large sampling of the new photography without the concessions and compromises required by the Philadelphia salons. Following the Philadelphia example of dual sponsorship, the Chicago Society of Amateur Photographers joined with the Art Institute of Chicago, one of the nation's most distinguished art museums, to hold the salon from April 1 through 18, 1900. A jury consisting primarily of photographers chose carefully: only 118 works were selected from approximately 900 entries. The first Chicago salon thus became a showcase for the best the American School had to offer. The second salon, October 1 through 22, 1901, was not so fortunate. Anti-elitist forces had been at work behind the scenes and, although Dyer tried to enlist Stieglitz's cooperation once again, the impresario must have been suspicious of the trend toward popularization and declined the offer. The second jury, moreover, was dominated by painters, a situation Stieglitz disapproved of, and their judgment was not nearly so selective as that of the previous jury. Accordingly, Stieglitz offered only lukewarm support to the show and sought to place the weight of his influence elsewhere.

At about the same time, another figure in the pictorial movement, the Boston-based photographer F. Holland Day, briefly tried to assume the mantle of leadership. Scholarly and mild-mannered, Day was an expert photographer in the soft-focus Symbolist tradition. His prints were much admired by Stieglitz, but the New Yorker felt threatened by Day's political power within the world of pictorial photography. This is largely because Day had taken the

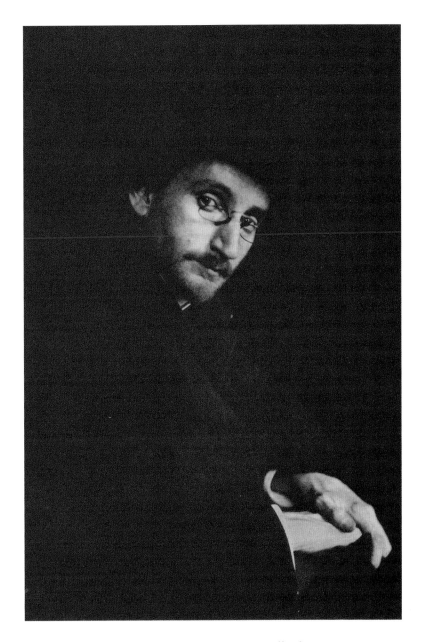

GERTRUDE KÄSEBIER ■ *Portrait of F. Holland Day, 1899.*

Photogravure, from *Camera Notes*, Lee Gallery, Winchester, Massachusetts.

initiative in arranging a vast photographic show called The New School of American Photography in London in 1900, which was repeated in Paris in 1901. Day had not only stolen Stieglitz's thunder, he had also attracted talented young pictorialists such as Edward Steichen and Alvin Langdon Coburn. When Stieglitz heard of the London show, he tried to derail it, claiming that some of the prints were of inferior quality. No matter: Day had scored a victory, and Stieglitz's leadership of the pictorial movement was challenged, if not seriously threatened. Documents from the period, including personal correspondence, indicate that Stieglitz, who was based in New York, was determined to take control from Day and his Boston colleagues.

In 1901 Stieglitz was in a quandary. He hoped to lead his supportive associates into some kind of institutional haven, outside of Day's orbit, but no easy solution presented itself. Some kind of secessionist move, though, was on his mind. In anticipation of the declining standards of the coming (1901) Philadelphia salon, Eva Watson-Schütze, a Philadelphia photographer who had moved into his circle, corresponded with him about plans for a new American salon. In a letter of April 21, she suggested "expanding your idea of privileged exhibitors for an organization—: Exhibitors in any one of the three Salons—say four—including Chicago, if advisable—being eligible for membership—the exhibition jury to be composed of all (present at the time for *duty!*) members whose work had been accepted at two successive Salons." She wrote of a new society that might give support to the salon: "There could be associates also who would help swell the fund. Surely fifty people at least would be ready to join such a Society—where there would be little chance to accuse any-one—jury or exhibitor—of favoritism."[1] How much Stieglitz had to do with these ideas may never be known, as his side of the correspondence is lost. But Watson-Schütze was clearly suggesting a group of national scope, with representatives from the key American centers where the new style of photography was flourishing.

Continually driven by the idea of secession, Stieglitz embarked on plans for an American salon free of the fetters imposed by Philadelphia and Chicago. In November 1901, through his friend, the critic Charles Caffin, he approached Paul Durand-Ruel's modern-art gallery in New York as a possible site, but the costs were too high. Further clues to Stieglitz's think-ing are revealed in the correspondence in January and February of 1902 between him and John Aspinwall, who was president of the Camera Club of New York. Judging from Aspinwall's responses, Stieglitz was planning to form a loosely organized "group of pictorial photographers and their patrons,"[2] with "no president no secretary no dues no club rooms no regular meetings."[3] Here we have the germ of the Photo-Secession as it was named and loosely defined in Stieglitz's National Arts Club exhibition of March 1902.

Besides Stieglitz, those who practiced advanced pictorial photography around the turn of the century include Edward Steichen, Gertrude Käsebier, Clarence White, Alvin Langdon Coburn, Frank Eugene, and Joseph Keiley—as well as F. Holland Day. (All but Coburn

were included in the 1902 show.) There were scores of others, too, equally sympathetic to Stieglitz's views. Author Robert Doty has successfully described the qualities that these photographers showed in their prints: "They worked toward a photography that went far beyond commonplace record, to expressions of beauty and spirit. Technique, once mastered, became unimportant, and the result had to be more than just an image on paper. Composition, massing of light and shade, correct rendition of tonal qualities, arrangement of lines, development of curves, were the means. With them they sought values, texture, character, any aspect which would appeal to the emotions of the viewer."[4]

■ There were two broad currents of photographic style within Stieglitz's circle, and both were acceptable to him. The line of division was drawn between those who believed in the straight photograph and those who followed a more painterly approach. Although there was an area between these two extremes in which qualities of both could be found, as in the work of Gertrude Käsebier, advocates of pictorial photography tended to group themselves around one pole or the other. The straight, unretouched photograph was championed primarily by Stieglitz, White, and Coburn, whereas others, such as Steichen and Eugene,

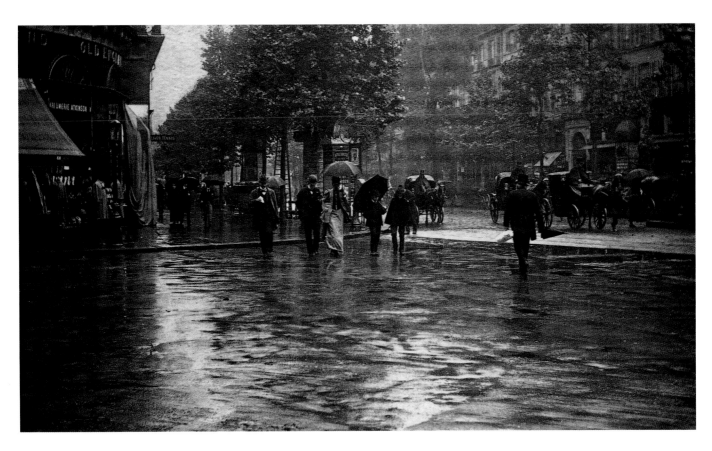

ALFRED STIEGLITZ ■ *A Wet Day on the Boulevard—Paris*, 1894.
Carbon, National Gallery of Art, Washington, D.C., Alfred Stieglitz Collection.

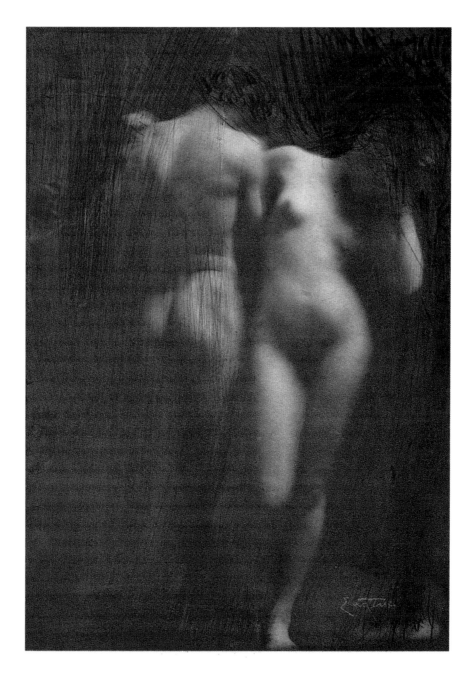

FRANK EUGENE ■ *Adam and Eve*, 1898. Photogravure, courtesy George Eastman House.

believed in the hand manipulation of the print, even the negative, which stressed the direct connection between painting and photography. Much effort was expended in the photographic press defending one side or the other, and it is to Stieglitz's credit that, although he did little manipulated work himself, he was willing to accept painterly prints by the best of his colleagues.

■ ■ ■

The National Arts Club was founded in 1898 at the initiative of Charles de Kay, a prolific writer of poetry, prose, and biography and, for eighteen years, an art and literary critic for the *New York Times.* He devoted his considerable energies to the formation of the club, persuad-

ing a group of prominent figures in the world of art and business to serve as an organizing committee. De Kay and his colleagues felt the club would fill a need both in the city and throughout the nation. A club publication stated the following about its purposes in 1901:

> To promote the acquaintance of art lovers and art workers in the United States one with another; to stimulate and guide toward practical expression the artistic sense of the American people; to maintain in the City of New York a clubhouse with such accommodation and appurtenances as shall fit it for social purposes in connection with art; to provide proper exhibition facilities for such lines of art, especially applied and industrial art, as shall not be otherwise adequately provided for in the same city; and to encourage the publication and circulation of news, suggestions and discussions relating to the fine arts.[5]

A clubhouse at 37 West Thirty-fourth Street was opened in May 1899, a location "in what is now [1901] and will be for the next decade the most central part of New York."[6] The response to this newcomer to the city's roster of clubs was immediate and enthusiastic—twelve hundred charter members signed on. Early members came from various art-related walks of life and included collectors Henry Clay Frick, Benjamin Altman, and Henry

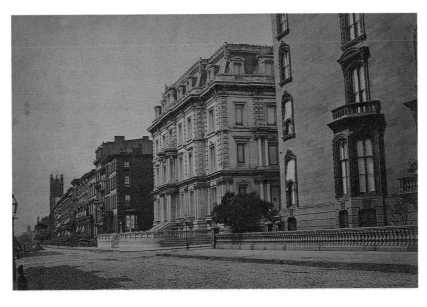

National Arts Club, 37–39 West Thirty-fourth Street, between Fifth Avenue and Broadway, New York, circa 1900. The club was located to the left of the A. T. Stewart mansion on the north side of the street in adjoining brownstones.

Walters; financier J. Pierpont Morgan; artists William Merritt Chase and Daniel Chester French; architect George B. Post; art critic Frank Jewett Mather; and museum director John W. Beatty of the Carnegie Institute. Many of the members were from New York City, but a sizable number also came from various cities across the nation. In both categories, there were socially prominent members, and women were accepted on the same basis as men. Both sociability (enhanced by a basement restaurant) and artistic uplift were fostered by the club. The latter activity took three forms: a monthly exhibition program, a lecture series given by experts on various topics, and a roster of musical concerts. Decorative and applied arts figured prominently in the first two offerings.

■ The National Arts Club exhibition schedule for the first season (1899–1900) featured objects such as pottery, small bronzes, rugs and embroideries, pastels, and leatherwork. An anonymous author (probably de Kay) writing about the club in 1901 noted, "Special fields of the Arts Club are the promotion of the arts and crafts, in order ultimately to improve the quality of our manufactures, and a stimulation of interest in the embellishment of cities and public buildings. Indeed the immediate success of the Arts Club was greatly due to public-spirited citizens interested in municipal development."[7] Shortly after that first very successful exhibition season, the club acquired and remodeled the building next door (39 West Thirty-fourth Street). This addition augmented the club's facilities and allowed for expansion of the galleries. A larger restaurant and sleeping rooms were added. The writer quoted above sang the praises of these enlarged facilities, which served as the clubhouse at the time of Stieglitz's Photo-Secession show:

> For the basement the extension allows more than double the former space
> to dining tables, a cloak room and a large kitchen in place of the grill; for
> the main floor the double gallery, large lounging rooms, dining room and
> small smoking room; for the second floor a library for art-books running
> the width of the clubhouse, a billiard room with two tables and a ladies'
> lounging room. The third and fourth floors furnish a dozen bed rooms
> with a bath room for every two chambers, and a couple of rooms for ste-
> nographers and committees.[8]

The gallery's second season, 1900 to 1901, was similar in character and emphasis to the first:

> The season 1900–1901 has been equally full and varied. An exhibit of objects of the arts and crafts in general was followed by one of artistic leatherwork and that by an exhibition of works of art in which birds and beasts enter, which in turn gave way for the exhibition under the care of the Library Committee composed of rare books and bindings, tools and implements of the engraver and half-toner, bookplates, color prints, Oriental books and ancient inscribed terra cottas from the Euphrates, as well as a colonial hand press, built in 1742, on which a souvenir was printed during the exhibition. Memorial exhibitions of works by deceased painters have been held several times in each season.[9]

In the third season (1901–1902), just prior to the Photo-Secession show, the club featured an exhibition of John La Farge's stained-glass windows, painting and sculpture by the Woman's Art Club, objects shown at the Pan-American Pacific Exhibition, ecclesiastical art, and one devoted to civic art under the auspices of the Municipal Art Society. No examples of pho-

Arts and Crafts exhibition, National Arts Club, November 28 to December 19, 1900.

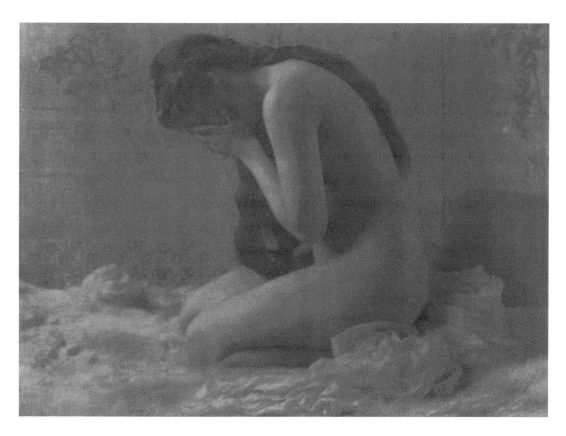

CHARLES I. BERG ■ *Weeping Magdalena,* circa 1898. Photogravure, private collection.

tographic art were shown at the club before Stieglitz's exhibition of 1902. The club's stress, one can easily see, was on the arts and crafts, with painting and sculpture playing a second-ary role. Photography, being a stepchild in the world of art—indeed, a kind of craft—made it somehow appealing and appropriate for the club to champion.

■ There is general agreement about the role Charles de Kay played in the 1902 exhibition. As managing director of the National Arts Club, he took the initiative and invited Stieglitz, a fellow member, to show his photographs there as a way of demonstrating the growing recognition of photography as an art. Stieglitz, however, decided that his point would best be made by a group show that included his own work. Receiving from de Kay "full power to follow his own inclinations," to use Stieglitz's own words,[10] he laid plans for a comprehensive display of the kind of American photography he believed in. The tone of Stieglitz's remarks suggests that he made the preparations single-handedly. However, photographic historian Weston Naef has pointed out that two members of the Camera Club of New York, Charles I. Berg and F. Benedict Herzog, had also joined the National Arts Club and helped

Stieglitz in the selection of the prints." Thus a jury of sorts played a role in this important event. Unfortunately, no records of the team's deliberations have been found, neither in the National Arts Club archives nor in the Stieglitz archive at Yale. However, articles and correspondence relating to the show, together with Stieglitz's recollections, shed some light on the matter.

Berg, a New York architect and a talented and successful amateur photographer, was a charter member of the Camera Club of New York, chairman of its print committee, and its vice president. In this capacity he had supervised the Camera Club's pioneering series of one-man exhibitions. He and Stieglitz quarreled from time to time, no doubt because of aesthetic differences. Even though Stieglitz reproduced several of Berg's photographs in *Camera Notes,* he must have cringed at the latter's trite, sentimental classicism. Herzog, on the other hand, was a friend to Stieglitz and a man of many talents. Besides his considerable skill as an amateur photographer, he was a patent attorney, an electrical engineer and inventor of electrical devices, and a painter who maintained a studio in New York City. Although Stieglitz did not reproduce his highly manipulated photographs in *Camera Notes,* he did include them in its successor, *Camera Work.*

Stieglitz claimed, on the catalogue cover, that the show was "arranged by 'The Photo-Secession'" but it appears that he, with the help of his colleagues, chose the entries. He made no secret of his firm control over the quality of the prints that were accepted and declared that he reserved "the right to reject such prints as were not the choicest examples of the subject extant."¹² In all, 162 photographs by 32 contributors were selected.

Invitation to the preview of the
1902 Photo-Secession exhibition at
the National Arts Club,
inscribed by Alfred Stieglitz.

The National Arts Club
New York

Nos. 37 and 39
West 34th Street

March 1902

At the request of *Alfred Stieglitz*

THE NATIONAL ARTS CLUB

asks the honor of the company of

M

in the galleries between two and six in the afternoon
to inspect a collection of

AMERICAN PICTORIAL PHOTOGRAPHS
arranged printed by members of the "Photo-Secession." The exhibition will close March 24th.

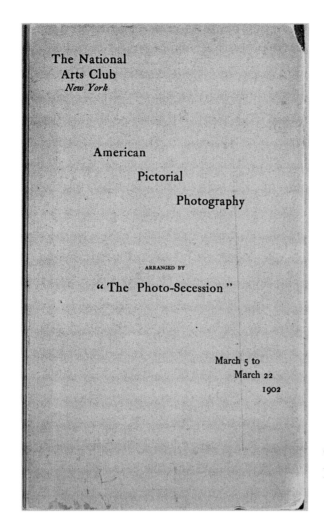

Catalogue cover, Photo-Secession exhibition, National Arts Club, 1902. Private collection.

■ The opening on March 5 was eventful not only for the photographs but also for the weather—a driving snowstorm. Stieglitz's young friend Edward Steichen recalled, years later, that the older man had addressed a distinguished audience on the subject of pictorial photography that day:

> In those days, New Yorkers had plenty of what it takes to leave the softer comforts of after-dinner hours and go out in a snowstorm for their art education. Transportation was by shoe leather, streetcars, and hansom cabs. New Yorkers came that night to find out what the shouting was for and to hear what Alfred Stieglitz had to say about it. The chronicles have it that the audience was distinguished and had an international flavour, for there came, not only New Yorkers like Richard Watson Gilder, editor of the *Century Magazine,* but also the Duke of Newcastle and Sir Philip Burne-Jones.[13]

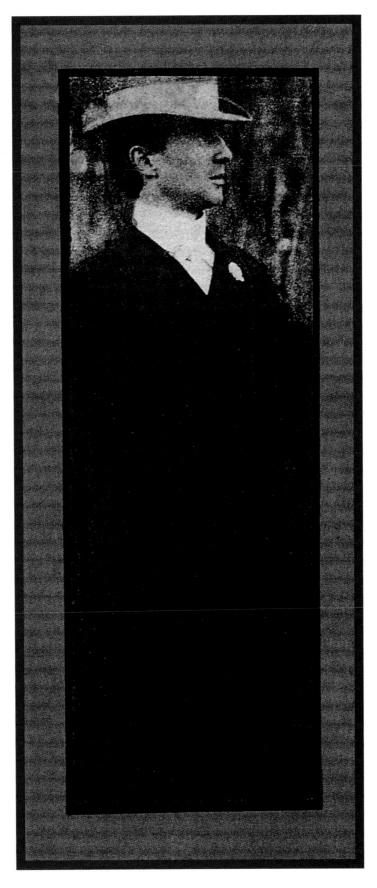

EDWARD STEICHEN ■ *Self-Portrait*, 1901. Private collection.

■ Once Stieglitz had secured the opportunity to lay the foundation for the American salon he had dreamed of for years, he needed to find (or invent) a suitable sponsoring body. In his later recollections, he told the story of how the Photo-Secession came into existence:

> As soon as de Kay had given me permission to go ahead he said, "Now we've got to have some publicity. What will we call this?"
>
> I said, "Anything you like—preferably *An Exhibition of American Photographs.*"
>
> "That will attract no attention," he said. "Why not *Exhibition of American Photographs arranged by the Camera Club of New York?*"
>
> "Why, the members of the Camera Club, the big majority, hate the kind of work I'm fighting for."
>
> "Well, why not *Exhibition of American Photographs arranged by Alfred Stieglitz?*" he said.
>
> "No, no, they'd hang me on the first lamp post.—That I wouldn't mind, but I don't want my name exploited." "De Kay," I said, "I've got it—it's a good one—call it *An Exhibition of American Photography arranged by the Photo-Secession.*"[14] [Stieglitz's memory for the actual title, printed on the catalogue cover, seems to have failed him.]

This makes a picturesque story, but Stieglitz's contemporary account dating from 1902, in a photographic journal, is doubtless closer to the truth. There he said he agreed to mount an exhibition that was "representative of *all* that was best in American photography according to modern ideas, rather than to hold only a one-man show. To achieve the end I had in view, I enlisted the aid of the then newly organized and limited 'Photo-Secession,' and it was determined to hold the forthcoming exhibition under the auspices of that group."[15] There was, of course, no group of any size. The Photo-Secession was Stieglitz's brainchild and consisted of little more than himself and those few photographers who had received his blessing.

■ As to the date of the founding of the Photo-Secession, Stieglitz's various publications give it as February 17, 1902, just a little more than two weeks before the National Arts Club

show's opening. Previous scholars have been mystified by the significance of the date, but Richard Whelan has pointed out that it corresponds to a heart-wrenching conflict between Stieglitz and two conservative members of the Camera Club of New York, Ferdinand Stark and C. N. Crosby, over the way in which photographs were to be judged and covered in *Camera Notes* and how the magazine would handle the results of the club's print competition.[16] Intentionally or not, these two had altered the terms of this agreement with Stieglitz, and, infuriated, he decided to go his own way.

■ The exhibitors who showed under the banner of the Photo-Secession were C. Yarnall Abbott, Prescott Adamson, Arthur E. Becher, Charles I. Berg, Alice Boughton, John G. Bullock, Rose Clark and Elizabeth Flint Wade, F. Colburn Clarke, F. Holland Day, Mary M. Devens, William B. Dyer, Thomas M. Edmiston, Frank Eugene, Dallett Fuguet, Tom Harris, Gertrude Käsebier, Joseph T. Keiley, Mary Morgan Keipp, Oscar Maurer, William B. Post, Robert S. Redfield, W. W. Renwick, Eva Watson-Schütze, T. O'Conor Sloane, Jr., Ema Spencer, Edward J. Steichen, Alfred Stieglitz, Edmund Stirling, Henry Troth, Mathilde Weil, and Clarence H. White. Stieglitz claimed that "all recognized workers of repute who had proven themselves in thorough sympathy with the spirit of the modern movement were invited to contribute, regardless of their photographic affiliations."[17]

■ The exhibitors were, indeed, a mixed lot, representing a variety of factions in the new photography and showing different degrees of artistic skill. Probably the best of the participants came from Stieglitz's circle, including disaffected members of the Camera Club of New York: Käsebier, White, and Keiley, together with Steichen and Eugene. A sizable group stemmed from Philadelphia, many of them veterans of the Philadelphia Photographic Society troubles: Redfield, Bullock, Watson-Schütze (now based in Chicago), Adamson, Stirling, Troth, and Weil. White's Newark, Ohio, circle was represented by Spencer and Edmiston, and the Boston contingent starred the enormously talented F. Holland Day and his follower, Mary M. Devens, from Cambridge. (Day never accepted Stieglitz's repeated invitations to join the Photo-Secession.) Selected figures of talent from various locales also played a role: Dyer in Chicago (the force behind the Chicago Salon); Maurer in San Francisco; Clark and Wade in Buffalo; Post in Fryeburg, Maine; Keipp in Selma, Alabama; and

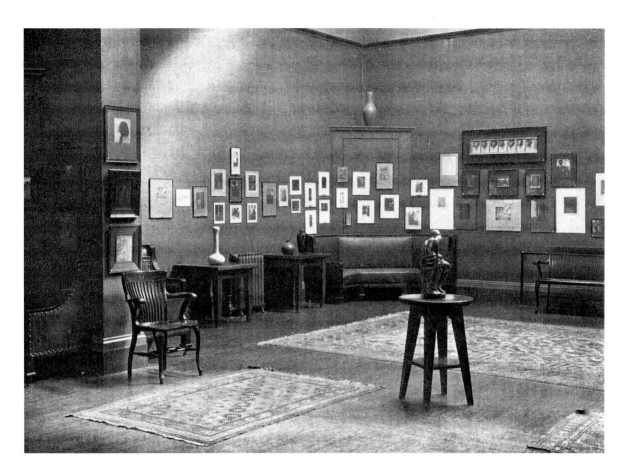

Photo-Secession exhibition at the National Arts Club, 1902. From *Camera Notes.* Photographer unknown.

Sloane in Orange, New Jersey. A handful of lesser New York–based photographers, some of them drawn from the Camera Club, also participated: Becher, Clarke, Fuguet, Harris, and Renwick. Two New York figures close this list: Boughton, a protégé of Käsebier, and Berg, an official of the New York Camera Club discussed above, who, with Herzog, is said to have helped Stieglitz prepare the 1902 exhibition. (Herzog's work was not included.)

Half of these exhibitors, Stieglitz claimed, had joined the Photo-Secession at the time of the exhibition; still, there was some confusion in the minds of some members about the new society. Käsebier's plight at the opening was later recounted by Stieglitz:

> "What's this Photo-Secession? Am I a photo-secessionist?"
> My answer was, "Do you feel you are?"
> "I do."
> "Well, that's all there is to it," I said.[18]

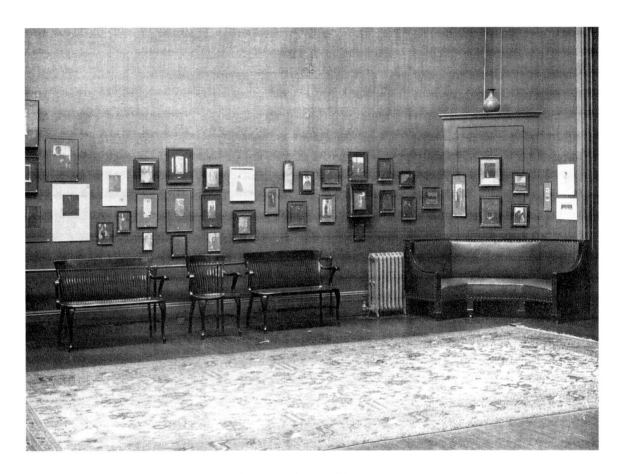

Photo-Secession exhibition at the National Arts Club, 1902. From *Camera Notes*. Photographer unknown.

These same subjective criteria could, of course, be applied in the opposite direction, this time in the case of Charles I. Berg, who had three prints in the show. Whelan points out, "When, at the opening, he asked whether he was a Photo-Secessionist, Stieglitz coldly informed him he was not."[19]

The term *Photo-Secession* seems to have been Stieglitz's invention, a replacement for the title "Pictorial League," which appeared in early correspondence about the National Arts Club show. Stieglitz was well aware of the link between his Photo-Secession ideas and those of the painters and sculptors in Vienna and Munich who had seceded from conservative parent organizations. His friend Steichen captured the spirit of secession in an impassioned article on the American School, published in London in 1901 and reprinted in *Camera Notes*:

> The secessionists of Munich—in fact, all secessions, and it is to a secession better than anything else that the new movement in photography can

be likened—gave, as the reason of their movement, the fact that they could no longer tolerate the convictions of the body from which they detached themselves, a body which exists on conventions and stereotyped formulae, that checked all spirits of originality instead of encouraging them, that refused its ear to any new doctrine—such groups gave birth to secession.[20]

A better statement of Stieglitz's secessionist idea would be hard to find. The argument, in fact, is so cogent that Stieglitz may well have been swayed by Steichen's stress on the word *secession* in concocting a name for the new movement.

▪ Fortunately, photographs that document the installation of American Pictorial Photography survive in the pages of *Camera Notes* and the Stieglitz archives at Yale. Compared to exhibitions today, the walls were hopelessly crowded, but by the standards of the time, the exhibition was tastefully arranged. Stieglitz's lieutenant, Joseph Keiley, in charge of the hanging, grouped together the images of each participant so that visitors could easily compare an individual print to the general direction of the photographer's work. The photographs of the National Arts Club galleries at 37–39 West Thirty-fourth Street were invaluable in reconstructing the contents of the show one hundred years after the event. We do not know who took them, but it was probably Stieglitz.

▪ Many of the photographs in the National Arts Club show had been exhibited before, but Stieglitz did not see this as a drawback. On the contrary, he felt that previous recognition, especially in notable foreign shows, would add to the prints' prestige. He proudly wrote the words that follow the list of works in the catalogue: "Many of these prints have been chosen from the pictures representing the United States at the International Exhibition of the Fine Arts of Glasgow 1901, the Photographic Salon at Paris 1901, the London Salon 1901 and the exhibition by the 'Secession' painters in Munich."

▪ The year 1901 was one of triumph for American photography abroad. Americans had won a sizable number of places in the Photo-Club de Paris and in London's Linked Ring sa-

lons, and the high quality of their work had been noted by many foreign critics. During the summer of 1901, the International Exhibition at Glasgow offered a prominent place to a group of approximately seventy photographs that Stieglitz had been asked to choose and send. This landmark exhibition, much applauded by Stieglitz, was the first time that a major international exposition had awarded photographs an equal place in the fine art section. No prizes were offered; works were included only by invitation, and that was, Stieglitz asserted, "the sole honor sought by those loving their art."[21]

In selecting the photographs for Glasgow, Stieglitz had engaged in a kind of dress rehearsal for the National Arts Club exhibition. For the latter he had wanted to show, through hand-picked prints from the years 1881 through 1900, "the various phases of what we dub the American school."[22] With some exceptions, the exhibitors at the club were the same as at Glasgow. For the 1902 show, however, Stieglitz weeded out Rudolf Eickemeyer, Jr., Zaida Ben-Yusuf, Emilie V. Clarkson, John E. Dumont, Mary R. Stanbery, and E. Lee Ferguson and added Becher, Boughton, Clarke, Fuguet, Keipp, Maurer, Renwick, Sloane, and Spencer. In sum, he eliminated conservatives and added more experimental workers for the New York exhibition.

Stieglitz's varied roster of photographers ensured that a wide spectrum of techniques would be represented, which was important to him. He wrote: "Not only was the exhibition national in the localities represented, but, strangely enough, all printing media from aristo to 'gum-bichromate' on the one hand, and bromide to 'glycerine platinotype' on the other, were embraced, thus showing that the Photo-Secessionist is committed to no other medium than that which best lends itself to his purpose."[23]

American Pictorial Photography won plaudits from the great majority of newspaper and magazine critics. As Stieglitz wrote to a friend, "The art critics, the best of them, are studying the pictures carefully, and some excellent articles have been written, and will be written, on the subject. Even the 'Century' is to open its pages to 'Photography as a Fine Art.'"[24] "Not all criticisms were equally favorable," Stieglitz admitted, but "even those hostile to the artistic claims of our craft appreciated the earnestness of the workers, and some went so far

as to admonish painters that for originality, feeling, seriousness, and truth underlying this whole exhibition they could learn much from these photographers."[25] He was no doubt pleased that four prints were sold from the show and that one exhibitor had refused an offer of three hundred dollars for a single photograph.

▪ After the National Arts Club show closed, Stieglitz had his own idea of what the exhibition had meant: "The interest displayed by the hordes of visitors amply repaid us for our efforts. For the first time the art-loving public of New York was made acquainted with the claims of photography for recognition as an art; and art critics, the public, and the National Arts Club unanimously accorded this exhibition a first place among the many exhibitions held in the galleries of that institution."[26] Of course, Stieglitz's goals were closely tied to his immediate personal and institutional ambitions for pictorial photography. From a vantage point of one hundred years later, we can see the event in a broader perspective. It was most important because it was a model group exhibition that visually stated the aims of the new photography. The show had all the earmarks of the American salon that Stieglitz had wished to institute—though there is no evidence that the National Arts Club wanted to make it an annual event. Nonetheless, Stieglitz had demonstrated that he could pull together the photographers he believed in under the loosely conceived heading of the Photo-Secession. The National Arts Club show taught him how to prepare and circulate Photo-Secession shows around the country and Europe. And it was, in a sense, the blueprint for the kind of American photography displays he mounted, along with European work, in one show after another at the Little Galleries of the Photo-Secession, starting in 1905.

▪ De Kay's invitation to Stieglitz to show his own work, supplemented by that of hand-picked photographers, came at just the right moment. Stieglitz was restless, dissatisfied, and searching for a way out of the Camera Club of New York frustrations. Tensions between him and its conservative members and officials had become unbearable, and the National Arts Club offer gave him a respectable alternative, a means of presenting something new in his own base of operations: New York City. Stieglitz had been thinking about secession for several years and the National Arts Club opportunity compelled him to take a position, to

invent a title and a structure of sorts for the new spirit that stirred within him. Inertia gave way to action, albeit at first tentative and unfocused.

On the negative side, the quality of work in the National Arts Club show did not entirely live up to the ideals that Stieglitz had publicly professed. To put it plainly, more than a few inferior photographers participated, and their prints fell below the best that could be expected of American workers. A glance at the installation views of the show reveals not only the prints of masters such as Stieglitz, Steichen, White, Käsebier, and Eugene, but also lesser lights working along similar lines. Among the works by the latter group whose creators can no longer be identified are a fair number of sentimental, maudlin images. Even in Stieglitz's own photographs, selected from the years 1892 through 1901, there are trite effects, as in *Scurrying Home* (1894) and *Gossip—Katwyk* (1894), that look more like imitations of paintings than freshly conceived photographs. His stress on "art" was a double-edged sword: photographers were supposed to be aware of artistic merit evidenced in painting and the graphic arts, but they ran the risk of imitating these mediums—both in style and in technique. Stieglitz was so eager, it seems, to defend the idea of photography as an art that he was willing, at least in 1901 and 1902, to accept every possible effort in that direction, even mediocre examples.

The National Arts Club and Stieglitz never came together again to produce an event like the 1902 show. There were, however, further points of contact. In 1908, the critic J. Nilsen Laurvik, a friend of Stieglitz's and a member of the Photo-Secession, organized an exceptional display called the Special Exhibition of Contemporary Art, on view at the club at its new (and current) headquarters at 15 Gramercy Park between January 4 and 25. This was the first and only time when painters of the Ashcan School (Robert Henri, John Sloan, William Glackens, George Luks, and Everett Shinn, for example) and a few other like-minded artists presented their work side by side with representatives of the Photo-Secession group, including Stieglitz, White, Käsebier, Eugene, Keiley, Boughton, and a newcomer, Alvin Langdon Coburn. Whereas historians usually stress the conflict and differences between these two groups, this National Arts Club show underlined the pertinent similarities, a perceptive step on Laurvik's part. He had hoped to stress the unity of all these artists in

ALFRED STIEGLITZ ■ *Scurrying Home,* 1894. Photogravure, courtesy George Eastman House.

Catalogue cover, Special Exhibition of Contemporary Art, National Arts Club, January 4 to January 25, 1908. Private collection.

Catalogue cover, International Exhibition of Pictorial Photography, National Arts Club, February 2 to February 20, 1909. Private collection.

combating the influence of the National Academy of Design and the then closely related organization, the Society of American Artists.

▥ Worth noting, in the club's early history, is the International Exhibition of Pictorial Photography held in 1909. A sweeping but selective historical survey of major photographic trends in the United States, England, France, Germany, and Austria, the show was originated by Laurvik, with Stieglitz serving as chairman of the hanging committee, other members being Coburn, Paul B. Haviland, George H. Seeley, White, and Laurvik himself, all of whom belonged to the Photo-Secession. Photo-Secessionists and several of their American sympathizers constituted the core of the show, an indirect but fruitful legacy of the original National Arts Club exhibition of 1902. Laurvik hailed this well-attended show, stating, "In its diversity of subject as well as treatment and in the high quality of its individual exhibits this show was far the best ever held in this country."[27]

It was the forward-looking element in the National Arts Club, personified by de Kay, that opened the institution's doors to a youthful and unproven medium—photography—in 1902. This gesture gave Stieglitz a taste of success, and the general acceptance of the show told him he was on the right track. One of the problems facing him, however, was how to define and organize the Photo-Secession. It was still little more than a mental construct, and for several months after the close of the 1902 show, it remained amorphous. From the literature of the period, one senses that Stieglitz was initially willing to let the Photo-Secession shape itself in reaction to events and needs as they arose. Letters and remarks from supporting friends, particularly Steichen, and articles by sympathetic writers urged him to give more definite structure to the Photo-Secession, however. He was apparently somewhat reluctant,

Photo-Secession "poster," designed by Edward Steichen, published in *Camera Work.*

Private collection.

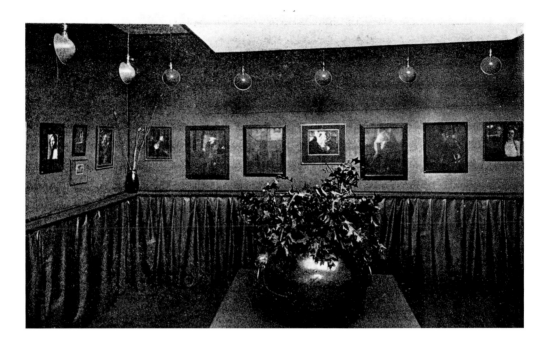

Photo-Secession exhibition at 291.
(Opening exhibition, November 24, 1905, to January 4, 1906.) From *Camera Work.* Private collection.

at the beginning, to shoulder this administrative responsibility, as evidenced by his early pronouncements that stressed only the spiritual ties among its members. Soon, however, he agreed to serve as director of the organization.

Between 1902 and 1905, Stieglitz fought for the principles of the Photo-Secession in the pages of the independent magazine he established, *Camera Work*, and through shows he circulated throughout the United States and Europe. Important as these functions were, the Photo-Secession lacked definition and public visibility. In 1905, Steichen proposed that the studio he had recently vacated on the top floor of 291 Fifth Avenue be converted into galleries. By doing this, Steichen suggested, a series of exhibitions could be held throughout the year that would show and explain the goals of the Photo-Secession to the public. After some hesitation, Stieglitz agreed to open a showplace, which he called "The Little Galleries of the Photo-Secession." From the beginning he and Steichen agreed to display pictorial photographs, both American and foreign, "as well as modern art not necessarily photographic."[28] However, the galleries were dedicated initially to shows of American and European photographs, presented one after another.

Just as painters of progressive tendency had rebelled against academic principles, so the photographers who gathered around Stieglitz, starting with the National Arts Club show,

Catalogue cover,
Contemporary Art exhibition,
National Arts Club,
February 5 to March 7, 1914.
Private collection.

rejected older forms of photography and strict codes or rules. Stieglitz and his colleagues stood for artistic independence, individuality, and freedom from convention, freedom for the photographers to express themselves in ways that they thought best. Accordingly, membership in the Photo-Secession was more a matter of intention than following a specific set of requirements, though photographic ability was definitely necessary.

■ It should be noted that Stieglitz gradually turned almost entirely away from photography to the promotion of avant-garde European and American painting and sculpture. A further connection of Stieglitz to the National Arts Club can be found in the club's mounting of an exhibition, in 1914, of advanced contemporary art in America, which was organized by Laurvik as a sequel to his show of contemporary art at the club in 1908. It featured younger American painters and pastelists, including Marsden Hartley, Arthur Dove, and John Marin, all three members of Stieglitz's circle and in various ways indebted to his encouragement and support. In this way Stieglitz and the National Arts Club came full circle, from painting to photography and back again, further promoting the cause of all things experimental and unconventional.

NOTES

1. Eva Watson-Schütze to Alfred Stieglitz, 21 April 1901. Beinecke Rare Book and Manuscript Library, Yale University (all cited correspondence is from this collection).

2. John Aspinwall to Alfred Stieglitz, 18 January 1902.

3. John Aspinwall to Alfred Stieglitz, 25 February 1902.

4. Robert Doty, *Photo-Secession: Photography as a Fine Art* (Rochester, N.Y.: The George Eastman House, 1960), 28.

5. *The National Arts Club* (New York, 1901), 15.

6. Ibid., 7.

7. Ibid., 6.

8. Ibid., 10.

9. Ibid., 10–11.

10. *Camera Notes* 5 (April 1902): 277.

11. Weston J. Naef, *The Collection of Alfred Stieglitz* (New York: The Viking Press, 1978), 110.

12. *Photograms of the Year, 1902* (New York, 1902): 18.

13. *Vogue* 97 (15 June 1941): 22.

14. *Twice a Year*, nos. 8–9 (Spring–Summer, Fall–Winter 1942): 116–117.

15. *Photograms of the Year, 1902*, 18.

16. Richard Whelan, *Alfred Stieglitz: A Biography* (Boston: Little, Brown, 1995), 178.

17. Ibid., 18.

18. *Twice a Year*, 117.

19. Whelan, *Stieglitz*, 183.

20. *The Photogram* 8 (January 1901): 4.

21. *Camera Notes* 5 (January 1902): 218.

22. *Camera Notes* 4 (April 1901): 273.

23. *Photograms of the Year, 1902*, 20.

24. Alfred Stieglitz to Dundas Todd, 17 March 1902, published in *British Journal of Photography* 49 (6 June 1902): 459.

25. *Photograms of the Year, 1902*, 18.

26. Ibid.

27. *Camera Work*, no. 26 (April 1909): 38.

28. Caption for Photo-Secession "poster," published in *Camera Work*, no. 13 (January 1906), n.p.

The 1902 Catalogue

▪ The following pages reproduce the original 1902 catalogue for the American Pictorial Photography Arranged by "The Photo-Secession" exhibition. The catalogue lists, presumably, all of the works that were included in the show, sometimes with dates, sometimes not. Occasionally, the catalogue's titles are slightly different from those we accept today, but on the whole there is a remarkable degree of uniformity. Some editorial errors, however, did creep in, and they are: catalogue no. 7, for "Mid" read " 'Midst"; catalogue no. 60, for "Master H." read "Master K. [Keim]"; and catalogue no. 66, for "Manager" read "Manger." Steichen, born in Luxembourg, usually used his given name, Eduard, until after World War I. At that point, he Americanized the spelling to "Edward."

The National
Arts Club
New York

American

Pictorial

Photography

ARRANGED BY

" The Photo-Secession "

March 5 to
March 22
1902

Catalogue

C. Yarnall Abbott, Philadelphia, Pa.

 1. The Darker Drink.
 2. A Study of a Head.
 3. The Dying Fire (1900).
 4. The Coryphée (1901).
 5. Dryad.

Prescott Adamson, Philadelphia, Pa.

 6. Snowstorm at Dusk.
 7. 'Mid Steam and Smoke.

Arthur E. Becher, Cleveland, O.

 8. Moonrise.
 9. A Flower.
 10. A Moonlight Poem.

Charles I. Berg, New York

 11. The Bath (1899).
 12. Portrait Sketch (1900).
 13. Decorative Panel (1900).

Alice Boughton.

 14. The Mountain-Side (1901).
 15. Beatrice (1901).

John G. Bullock, Germantown, Pa.

 16. The Coke Burner (1900).
 17. The White Wall (1901).

Rose Clark and Elizabeth Flint Wade, Buffalo, N. Y.

 18. Annetje.
 19. Out of the Past.
 20. Doris and Her Mother.

F. Colburn Clarke, New York

 21. Nude (1901).

F. HOLLAND DAY, Boston, Mass.

22. A Study in Grays: Portrait of Miss H. (1901).
23. Madame Georget LeB. (1901).
24. The Seven Words (1899).
 I. " Father, forgive them; they know not what they do."
 II. " To-day thou shalt be with Me in Paradise."
 III. " Woman, behold thy son; son, thy mother."
 IV. " My God! my God! why hast Thou forsaken me ? "
 V. " I thirst."
 VI. " Into Thy hands I commend my spirit."
 VII. " It is Finished."
25. Vas Lacrimarum.
26. A Street in Algiers (1901).
27. The Favored Pupil.
28. The Sacred Tree (1901).
29. Menelek.
30. Vita Mystica.
31. Monsieur Maurice Maeterlinck (1901).
32. Monsieur Robert Demachy (1901).

MARY M. DEVENS, Cambridge, Mass.

33. The Fountain—Amalfi.
34. La Grandmère.
35. The Convent Wall.
36. Market Day—Brittany.
37. Portrait.

WM. B. DYER, Chicago, Ill.

38. The Sledge (1901).
39. Nude (1900).
40. Portrait—Ralph Clarkson (1900).
41. Head in Red (1899).
42. Autumn.
43. Defiance (1901).
44. Ill Will (1901).
45. The Model.
46. Illustration to "Walden Pond" (1902).
47. " " " " (1902).
48. Wild Rose (1900).
49. Landscape (1900).
50. Fantasy (1900).
51. Clytie (1900).

THOS. M. EDMISTON, Newark, O.

 52. Carving the Name (1900).
 53. In the Woods (1900).

FRANK EUGENE, New York

 54. Adam and Eve (1898).
 55. La Cigale (1898).
 56. Portrait—Alfred Stieglitz (1900).
 57. Dogwood (1898).
 58. Nude (1899).
 59. Man in Armor (1898).
 60. A Portrait of Master H.
 61. Portrait—Miss Jones.
 62. Nude.
 63. Song of the Lily.

DALLETT FUGUET, New York

 64. The Street.

TOM HARRIS (deceased).

 (Lent by Mr. Stieglitz).
 65. Portrait—Sadakichi Hartmann (1898).

GERTRUDE KÄSEBIER, New York

 66. The Manager (1899).
 67. Blessed Art Thou Among Women (1899).
 68. The Red Man (1901).
 (Lent by Col. A. A. Pope, Cleveland, O.).
 69. Harmony (1901).
 70. The Young Mother (1900).
 71. The Anatomist (1902).
 72. Portrait.
 73. Portrait of a Man (1900).
 74. Man with the Hat (1902).
 75. Portrait—Clarence H. White (1902).
 76. Mother and Child (1900).
 (Lent by Col. A. A. Pope).
 77. Serbonne (1901).
 78. Family Group (1902).
 79. Sunrise (1901).

JOSEPH T. KEILEY, Brooklyn, N. Y.

80. Zitkala-Sa (1898).
81. The Rising Moon (1900).
82. Garden of Dreams (1899).
83. The Erlking (1899).
84. The Ruin (1901).
85. Sioux Indian Girl (1898).
86. Indian Warrior (1898).
87. Pennsylvania Landscape (1898).
88. Reverie—The Last Hour (1901).
89. A Study in Flesh Tones (1899).
90. A Bacchante (1899).
91. The Coiffure (1897).
92. Forest Stream (1885).
93. Winter Landscape (1897).
94. Over the Hedge (1901).

MARY MORGAN KEIPP, Selma, Ala.

95. "Beyon'." (1901).

OSCAR MAURER, San Francisco, Cal.

96. After the Storm (1900).
 (Lent by The Rotograph).

WM. B. POST, Fryeburg, Me.

97. Winter—Intervale (1899).
98. Lovewell's Pond (1899).

ROBERT S. REDFIELD, Philadelphia, Pa.

99. A New England Landscape.
100. The Brook—Spring.

W. W. RENWICK, New York.

101. Nude.

EVA WATSON-SCHÜTZE, Chicago, Ill.

102. Iris.
103. A Morning Picture.
104. Dreams.
105. Willows.
106. The Storm.
107. The Children's Refuge.
108. The Toy.
109. Omar Khayyam LXVIII.

T. O'Conor Sloane, Jr., Orange, N. J.
 110. A Head.

Ema Spencer, Newark, O.
 111. A Mute Appeal.

Eduard J. Steichen, Milwaukee, Wis.
 (temporarily Paris, France).
 (Lent by Mrs. Käsebier).
 112. The Black Vase (1901).
 113. Self-Portrait (1901).
 114. Wood Interior (1901).
 115. Winter Effect (1901).
 116. The Critic (1901).
 117. Portrait—Franz von Lenbach (1901).
 118. Portrait—Otto Stuck (1901).
 119. The Pool (1899).
 120. Rodin—I (1901).
 121. Rodin—II (1901).
 (Lent by Mr. Stieglitz).
 122. Evening (1899).
 123. Winter Landscape (1899).
 124. The Lamp (1899).
 125. Self-Portrait—Poster Design (1899).

Alfred Stieglitz, New York
 126. The Net-Mender (1894).
 127. Winter—Fifth Avenue (1892).
 128. Watching for the Return (1894).
 129. Scurrying Home (1894).
 130. Decorative Panel (1894).
 131. An Icy Night (1897).
 132. September (1896).
 133. Katwyk Beach (1894).
 134. At Anchor (1894).
 135. Spring (1901).
 136. A Vignette in Oxalate and Mercury (1898).
 137. Spring Showers—The Street Sweeper (1901).
 138. Gossip—Venice (1894).
 139. Gossip—Katwyk (1894).
 140. The Street Paver, New York (1892).
 141. Portrait of Mr. R. (1895).
 142. A Study in Lighting.

EDMUND STIRLING, Philadelphia, Pa.

 143. Bad News.
 144. The Drawing Lesson.
 145. Old Wedding Dress.

HENRY TROTH, Philadelphia, Pa.

 146. In The Fold.

MATHILDE WEIL, Philadelphia, Pa.

 147. Hydrangeas.
 148. Return of the Fleet.
 149. Off the Track.

CLARENCE H. WHITE, Newark, O.

 150. The Ring Toss (1900).
 151. Spring (1898).
 152. Telegraph Poles (1900).
 153. The May Pole (1899).
 154. Twilight.
 155. Portrait of Mrs. H. (1898).
 156. Letitia Felix.
 157. Nude (1900).
 158. Portrait—Miss L. F.
 159. Andante (1900).
 160. Portrait—Miss Gilbert.
 161. The Vision.
 162. Penseroso.

NOTE: Many of these prints have been chosen from the pictures representing the United States at the International Exhibition of the Fine Arts of Glasgow 1901, the Photographic Salon at Paris 1901, the London Salon 1901 and the exhibition by the "Secession" painters in Munich.

Any persons wishing to know further particulars concerning prices of prints, concerning exhibitors and the organization "Photo-Secession" may address Mr. Alfred Stieglitz, No. 3 West 29th Street, Manhattan.

Author's Note to the Plates

◼ Every effort has been made to reconstruct the 1902 Photo-Secession show. This, however, was not an easy task. For guidelines, two sources of information were used. The first was the original 1902 catalogue, published here, whose entries gave only the titles and sometimes the dates of the works on display. The second document was the set of three installation photographs, probably taken by Stieglitz, published in *Camera Notes*. Many hours were spent matching known prints with those seen on the walls at the National Arts Club and finding the actual works in public and private collections. The result has been an approximate reconstruction of this important show. The disappearance of some of the photographs and the loss of useful records have made it impossible to do the job perfectly. Thus prints by several photographers who participated in the exhibition are not included among the plates in this book.

◼ I have dated as closely as possible the photographs reproduced in the plates. In some cases there was no specific date to be found, so I have proposed an approximate date. When Stieglitz provided dates for the 1902 exhibition catalogue, he was not always accurate; hence, there may be discrepancies between his dates and mine.

◼ The dates presented here are those associated, in each case, with the making of the original negatives. It is possible, of course, that the photographers could have produced prints in subsequent years or, indeed, that photogravures were made from these images at a later date.

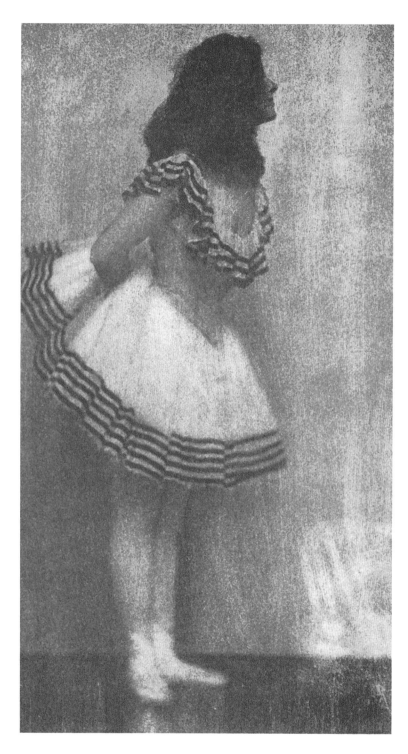

C. YARNALL ABBOTT ■ *A Coryphée*, 1901.

Halftone, courtesy George Eastman House.

PRESCOTT ADAMSON ■ *'Midst Steam and Smoke,* circa 1898.

Photogravure, courtesy George Eastman House.

ARTHUR E. BECHER ■ *Moonlight (A Moonlight Poem)*, circa 1900.

Colored halftone, courtesy George Eastman House.

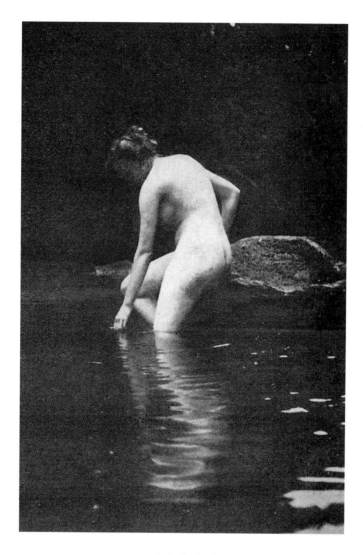

CHARLES I. BERG ■ *The Bath,* circa 1900.

From Charles H. Caffin, *Photography as a Fine Art* (New York: Doubleday, Page & Co., 1901).

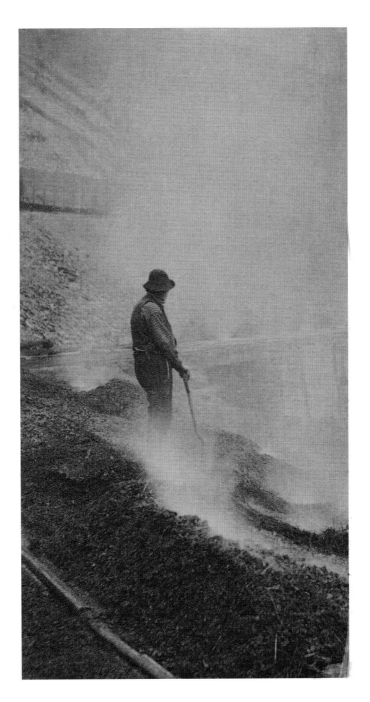

JOHN G. BULLOCK ■ *The Coke Burner*, 1900.

Photogravure, courtesy George Eastman House.

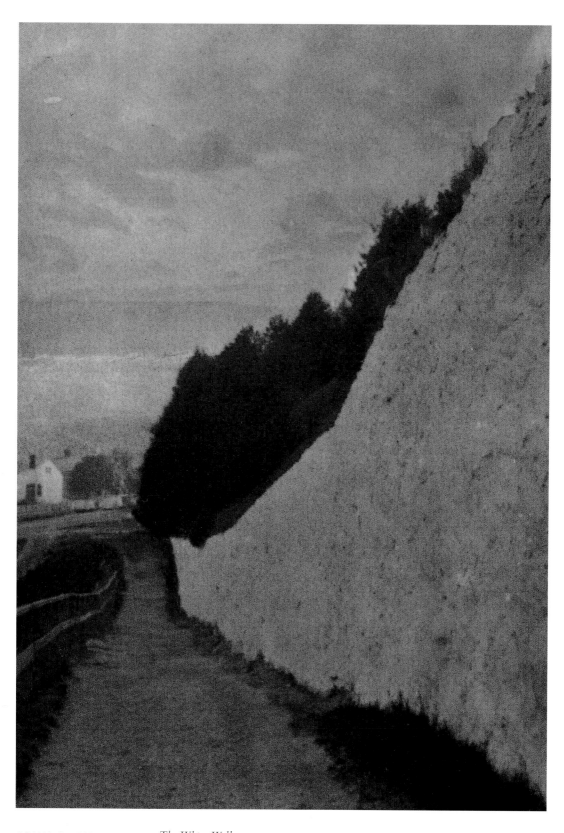

JOHN G. BULLOCK ■ *The White Wall,* 1901.

Glycerine-developed platinum, The Metropolitan Museum of Art, The Alfred Stieglitz Collection, 1933.

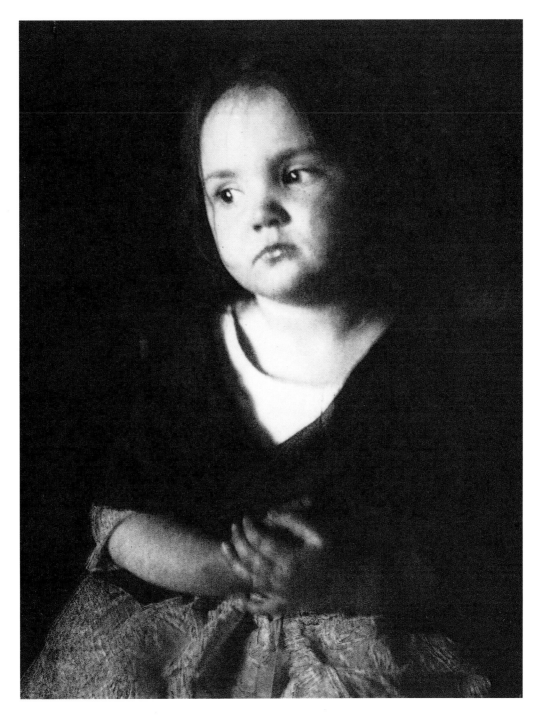

ROSE CLARK AND ELIZABETH FLINT WADE ■ *Annetje,* 1898.

Platinum, The Metropolitan Museum of Art, The Alfred Stieglitz Collection, 1933.

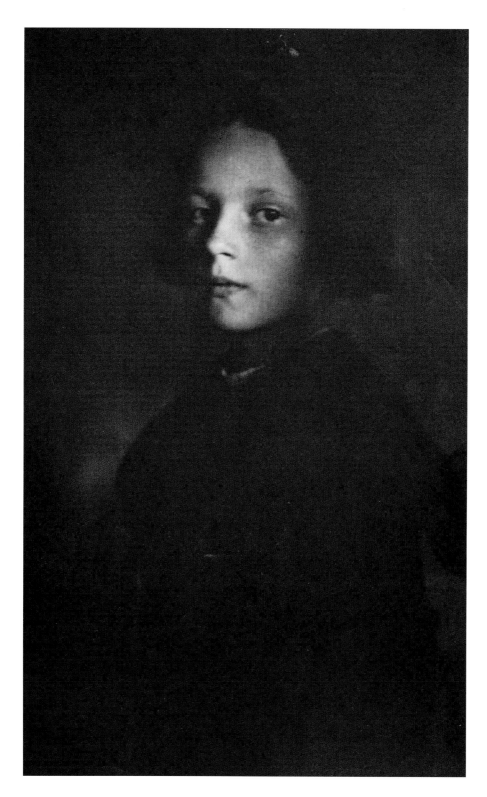

ROSE CLARK AND ELIZABETH FLINT WADE ■ *Out of the Past,* 1898.

Platinum, The Metropolitan Museum of Art, The Alfred Stieglitz Collection, 1933.

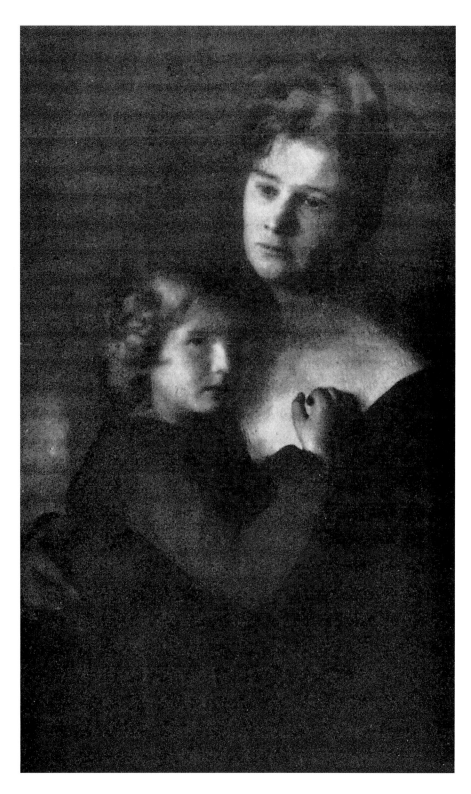

ROSE CLARK AND ELIZABETH FLINT WADE ■ *Doris and Her Mother*, circa 1899.

From *Catalogue of Third Philadelphia Photographic Salon* (Philadelphia: The Pennsylvania Academy of the Fine Arts and the Photographic Society of Philadelphia, 1900).

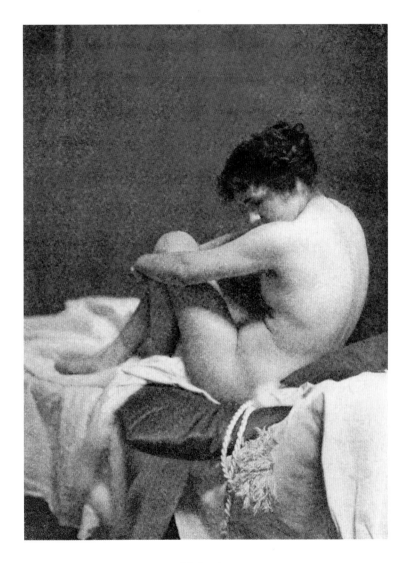

F. COLBURN CLARKE ■ *Nude*, circa 1900.

Halftone, courtesy George Eastman House.

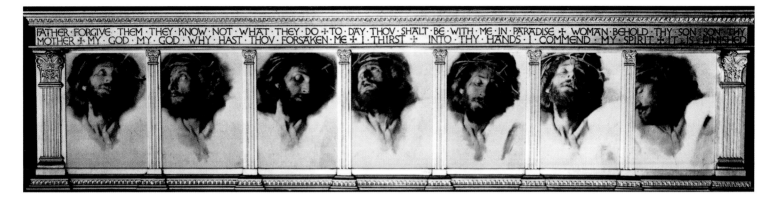

F. HOLLAND DAY ■ *The Seven Words*, 1898.

Platinum, The Metropolitan Museum of Art, The Alfred Stieglitz Collection, 1949.

F. HOLLAND DAY ■ *A Street in Algiers*, 1901.

Platinum, Royal Photographic Society, Bath.

F. HOLLAND DAY ■ *The Sacred Tree*, 1900.

Platinum, Royal Photographic Society, Bath.

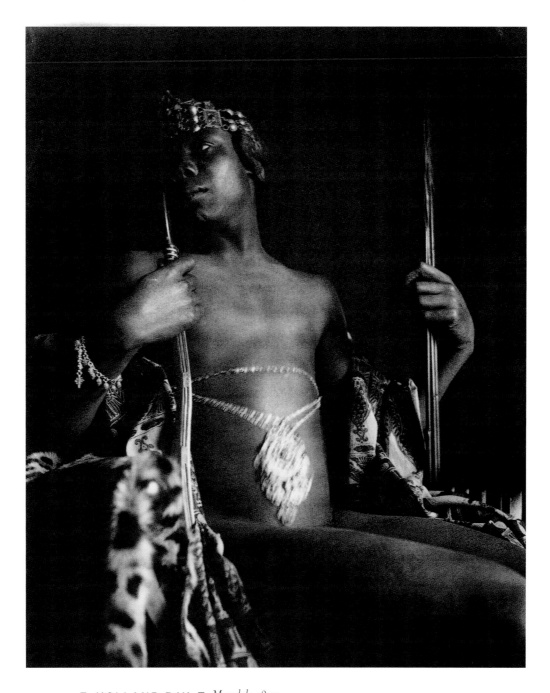

F. HOLLAND DAY ■ *Menelek, 1897.*

Platinum, The Metropolitan Museum of Art, The Alfred Stieglitz Collection, 1933.

F. HOLLAND DAY ■ *Vita Mystica*, 1901.

Platinum, The J. Paul Getty Museum, Los Angeles.

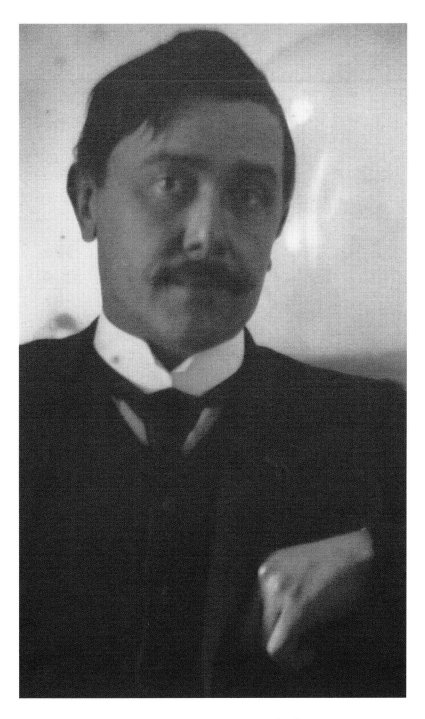

F. HOLLAND DAY ■ *Monsieur Maurice Maeterlinck,* 1901.

Platinum, Royal Photographic Society, Bath.

MARY M. DEVENS ■ *La Grandmère,* 1900.

Gray pigment gum bichromate over platinum, The Metropolitan Museum of Art, The Alfred Stieglitz Collection, 1933.

WILLIAM B. DYER ■ *Clytie,* 1899.

Photogravure, courtesy George Eastman House.

FRANK EUGENE ■ *Adam and Eve*, 1898.

Photogravure, courtesy George Eastman House.

FRANK EUGENE ■ *La Cigale,* 1898.

Photogravure, courtesy George Eastman House.

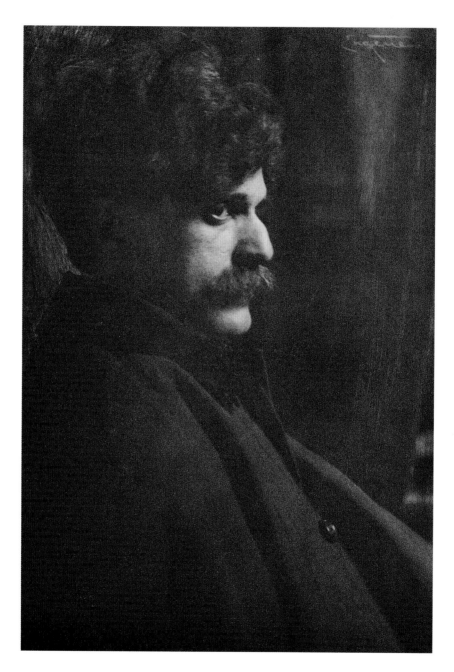

FRANK EUGENE ■ *Portrait of Alfred Stieglitz,* 1900.

Photogravure, courtesy George Eastman House.

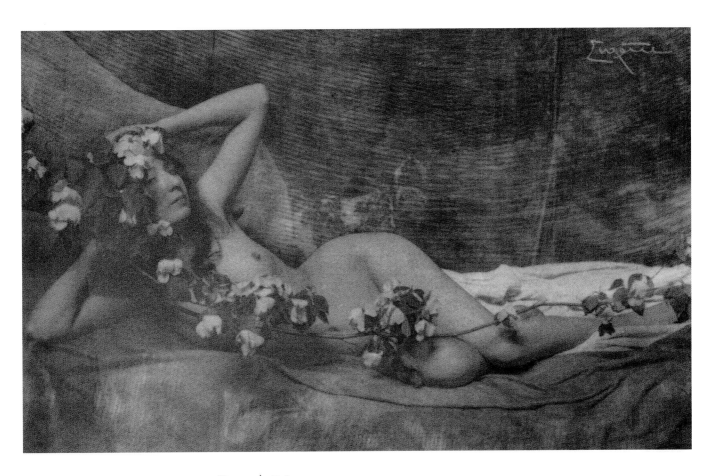

FRANK EUGENE ■ *Dogwood*, 1898.

Platinum, The Metropolitan Museum of Art, Rogers Art Fund, 1972.

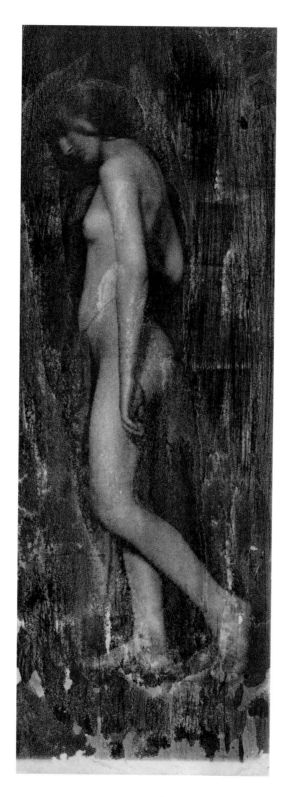

FRANK EUGENE ■ *Nude,* not later than 1900.

Platinum, The Metropolitan Museum of Art, The Alfred Stieglitz
Collection, 1949.

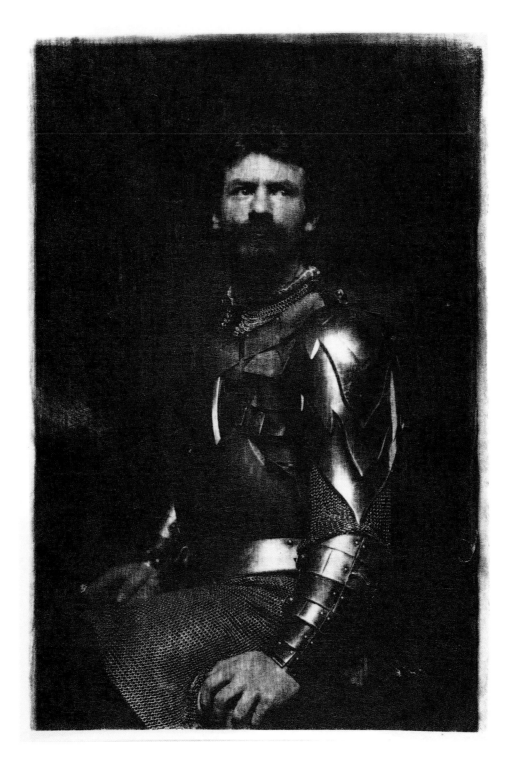

FRANK EUGENE ■ *The Man in Armor (Self-Portrait)*, 1898.

Platinum, The Metropolitan Museum of Art, The Alfred Stieglitz Collection, 1933.

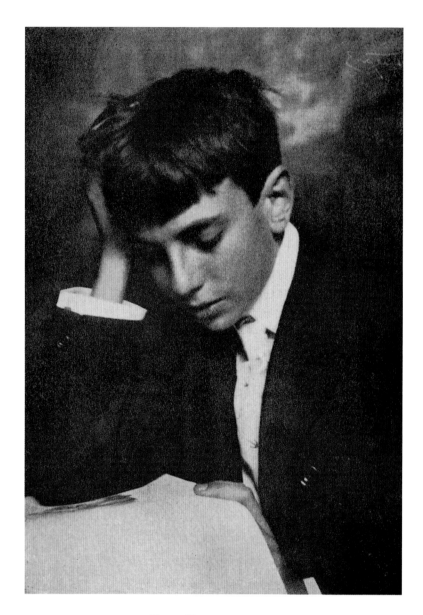

FRANK EUGENE ■ *Master Keim, 1897.*

Halftone, courtesy George Eastman House.

FRANK EUGENE ■ *Portrait—Miss Jones,* circa 1899.

Photogravure, courtesy George Eastman House.

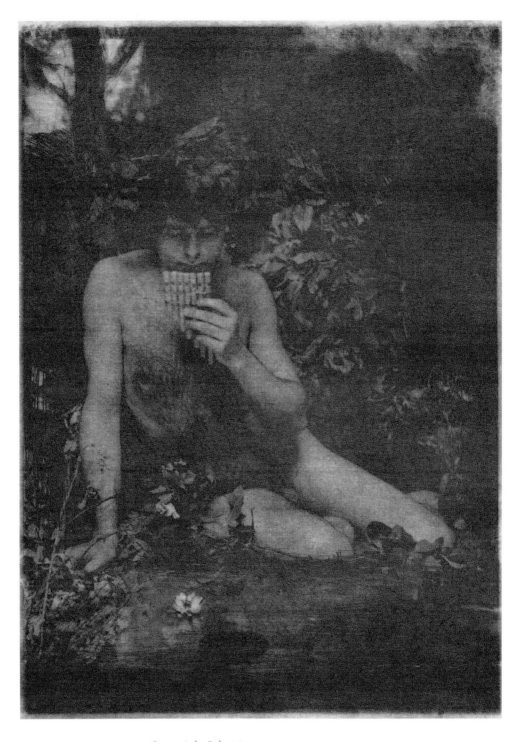

FRANK EUGENE ■ *Song of the Lily*, 1897.

Platinum on tissue, The Metropolitan Museum of Art, The Alfred Stieglitz Collection, 1933.

DALLETT FUGUET ■ *The Street,* circa 1900.

Photogravure, courtesy George Eastman House.

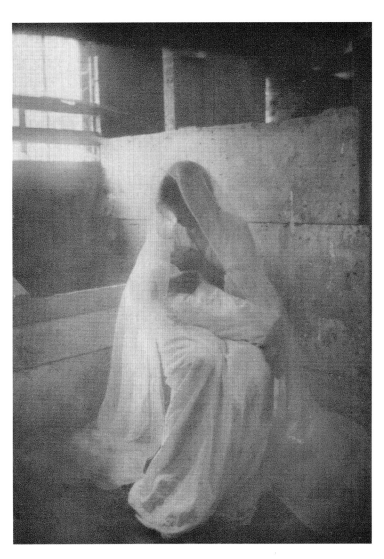

GERTRUDE KÄSEBIER ■ *The Manger,* 1899.

Photogravure, courtesy George Eastman House.

GERTRUDE KÄSEBIER ■ *Blessed Art Thou Among Women*, 1899.

Platinum, The Metropolitan Museum of Art, The Alfred Stieglitz Collection, 1933.

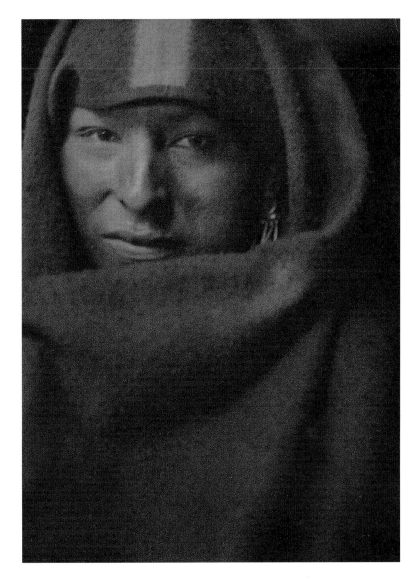

GERTRUDE KÄSEBIER ■ *The Red Man,* circa 1900.

Photogravure, courtesy George Eastman House.

GERTRUDE KÄSEBIER ■ *Harmony (Family)*, 1901.

Platinum, The Museum of Modern Art, New York. Gift of Mrs. Hermine M. Turner. Copyright 2001, The Museum of Modern Art.

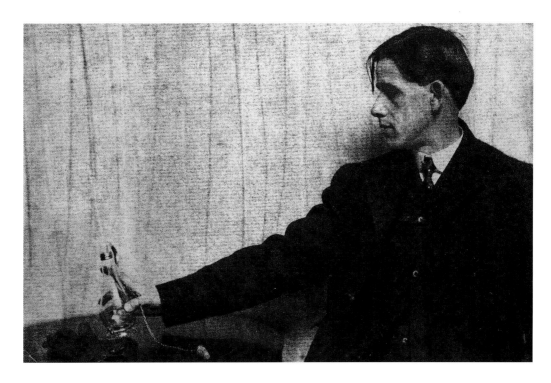

GERTRUDE KÄSEBIER ■ *Portrait—Clarence H. White, Esquire,* before 1899.

Gum bichromate, The Metropolitan Museum of Art, The Alfred Stieglitz Collection, 1933.

GERTRUDE KÄSEBIER ∎ *Serbonne,* 1901.

Photogravure, courtesy George Eastman House.

GERTRUDE KÄSEBIER ■ *Family Group,* 1902.

Platinum, The Metropolitan Museum of Art, The Alfred Stieglitz Collection, 1933.

JOSEPH T. KEILEY ■ *Zit-Kala-Za*, 1898.

Glycerine-developed platinum, The Metropolitan Museum of Art, The Alfred Stieglitz Collection, 1933.

JOSEPH T. KEILEY ■ *Garden of Dreams,* 1899.

Photogravure, courtesy George Eastman House.

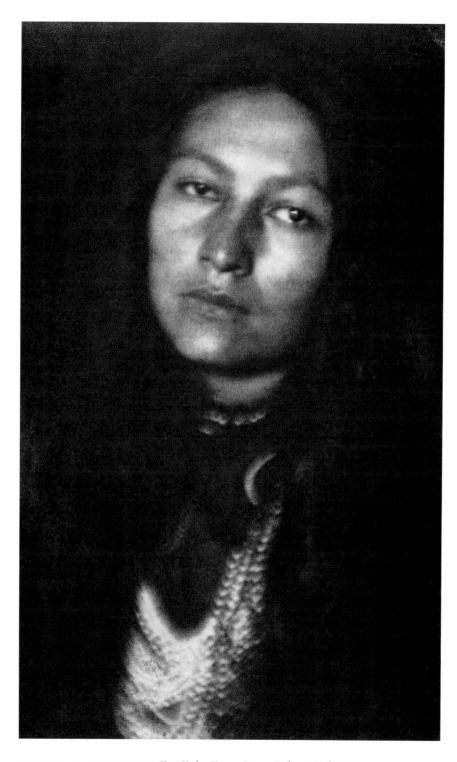

JOSEPH T. KEILEY ■ *Zit-Kala-Za* or *Sioux Indian Girl*, 1898.

Glycerine-developed platinum. The Metropolitan Museum of Art, The Alfred Stieglitz Collection, 1949.

JOSEPH T. KEILEY ■ *A Sioux Chief* or *Indian Warrior*, 1898.

Platinum, The Metropolitan Museum of Art, The Alfred Stieglitz Collection, 1933.

JOSEPH T. KEILEY ■ *A Pennsylvania Landscape*, 1900.

Platinum, The Metropolitan Museum of Art, The Alfred Stieglitz Collection, 1933.

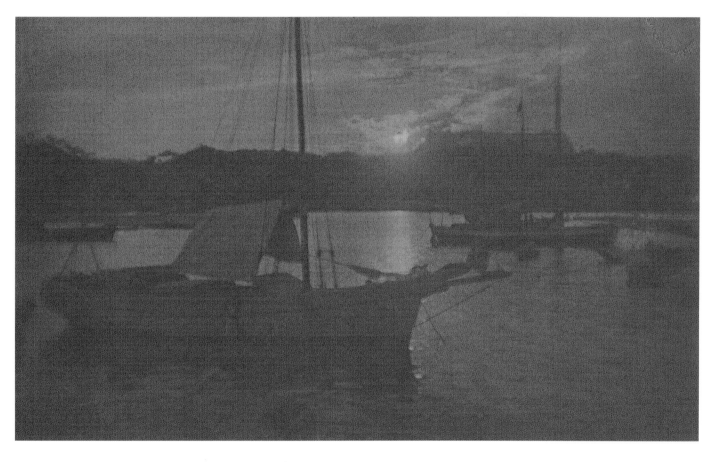

JOSEPH T. KEILEY ■ *Reverie: The Last Hour*, 1901.

Platinum, The Metropolitan Museum of Art, The Alfred Stieglitz Collection, 1933.

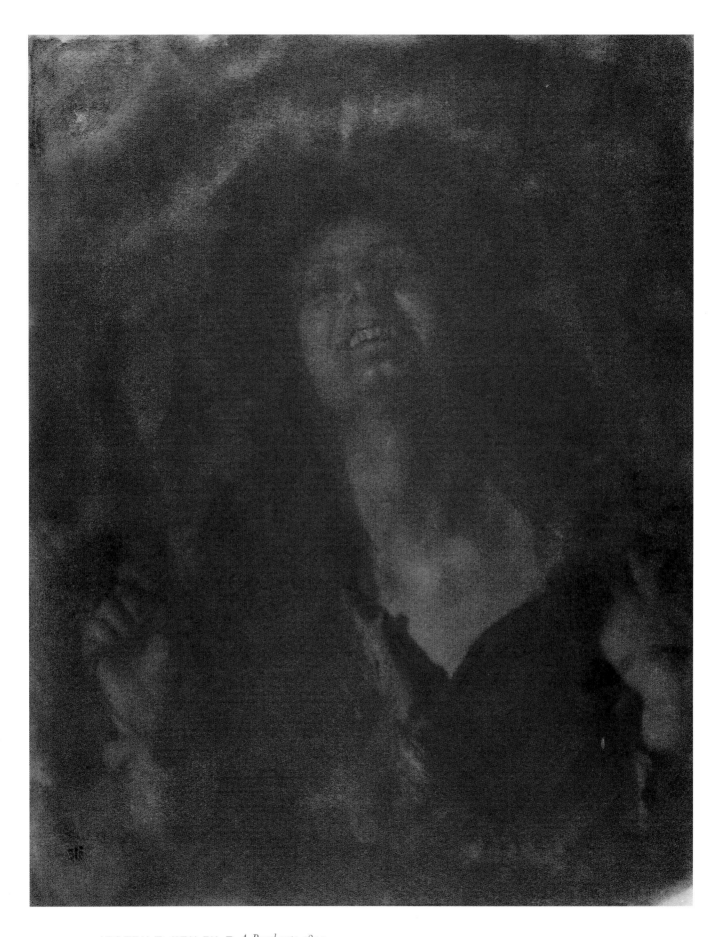

JOSEPH T. KEILEY ■ *A Bacchante,* 1899.

Glycerine-developed platinum, The Metropolitan Museum of Art, The Alfred Stieglitz Collection, 1933.

JOSEPH T. KEILEY ■ *Winter Landscape*, 1898.

Platinum, The Metropolitan Museum of Art, The Alfred Stieglitz Collection, 1949.

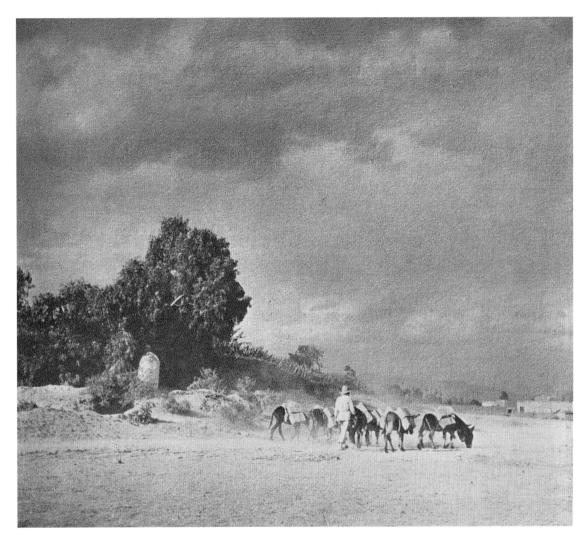

OSCAR MAURER ■ *Approaching Storm*, 1900.

Photogravure, courtesy George Eastman House.

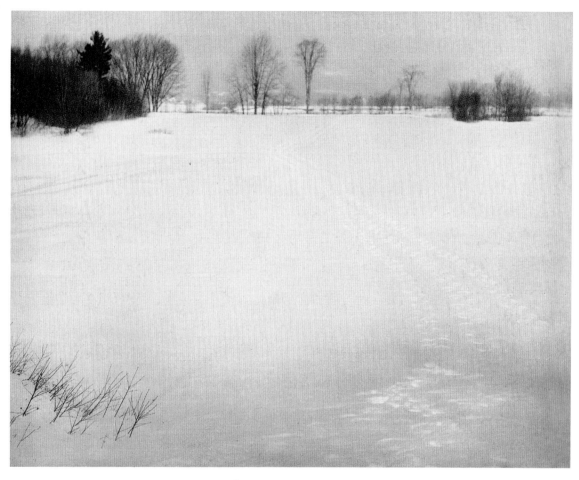

WILLIAM B. POST ■ *Winter—Intervale,* 1899.

Photogravure, courtesy George Eastman House.

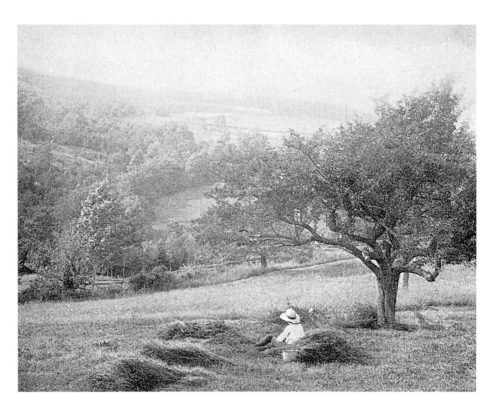

ROBERT S. REDFIELD ■ *A New England Landscape,* circa 1899.

Halftone, courtesy George Eastman House.

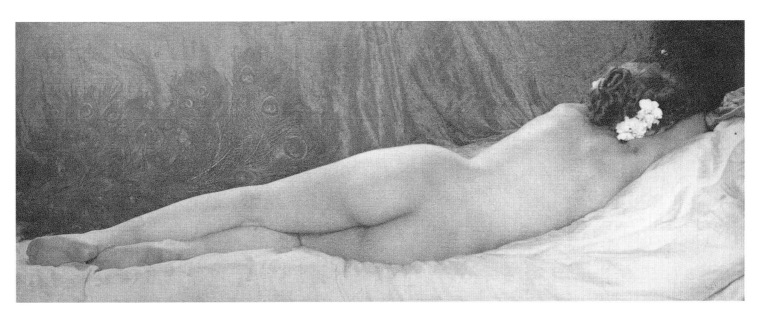

W. W. RENWICK ■ *Nude*, circa 1900.

Photogravure, courtesy George Eastman House.

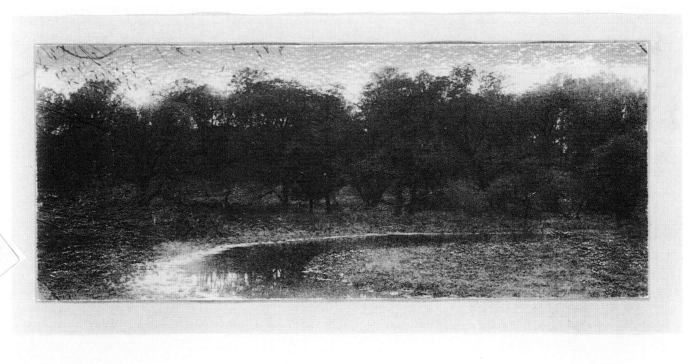

EVA LAWRENCE WATSON-SCHÜTZE ■ *Willows*, circa 1898.

Platinum, The J. Paul Getty Museum, Los Angeles.

EVA LAWRENCE WATSON-SCHÜTZE ■ *The Storm,* circa 1902.

Glycerine-developed platinum, The Metropolitan Museum of Art, The Alfred Stieglitz Collection, 1949.

EVA LAWRENCE WATSON-SCHÜTZE ■ *The Toy*, circa 1898.

Platinum, The J. Paul Getty Museum, Los Angeles.

EMA SPENCER ■ *A Mute Appeal,* circa 1900.

From *Catalogue of Third Philadelphia Photographic Salon* (Philadelphia: The Pennsylvania
Academy of the Fine Arts and the Photographic Society of Philadelphia, 1900).

EDWARD J. STEICHEN ■ *The Black Vase*, 1901, printed 1902.

Direct carbon, The Metropolitan Museum of Art, The Alfred Stieglitz Collection, 1933.

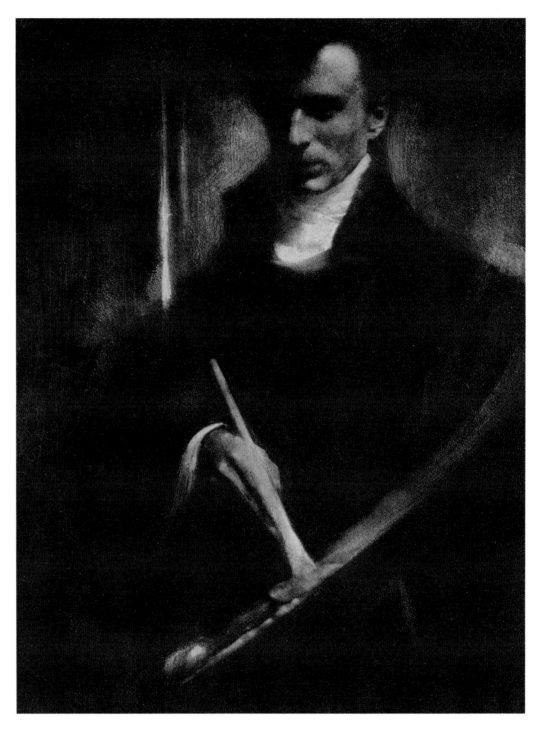

EDWARD J. STEICHEN ■ *Self-Portrait with Brush and Palette*, 1901.

Gum bichromate, courtesy of the Art Institute of Chicago.

EDWARD J. STEICHEN ■ *Woods Interior*, 1898.

Platinum, The Metropolitan Museum of Art, The Alfred Stieglitz Collection, 1933.

EDWARD J. STEICHEN ■ *Winter Effect* or *Moonlight—Winter,* 1902.

Gum bichromate over platinum, The Metropolitan Museum of Art, The Alfred Stieglitz Collection, 1933.

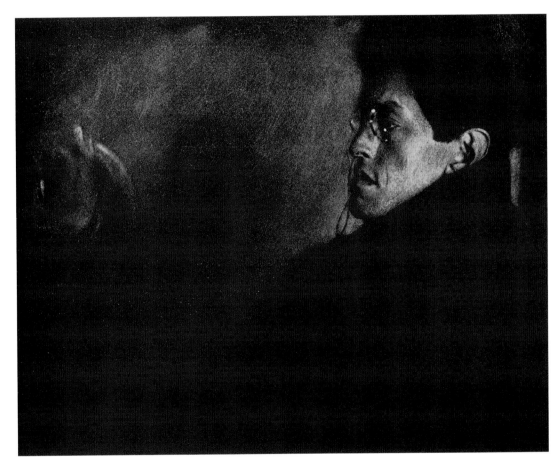

EDWARD J. STEICHEN ■ *The Critic* [Sadakichi Hartmann], circa 1901.

Photogravure, courtesy George Eastman House.

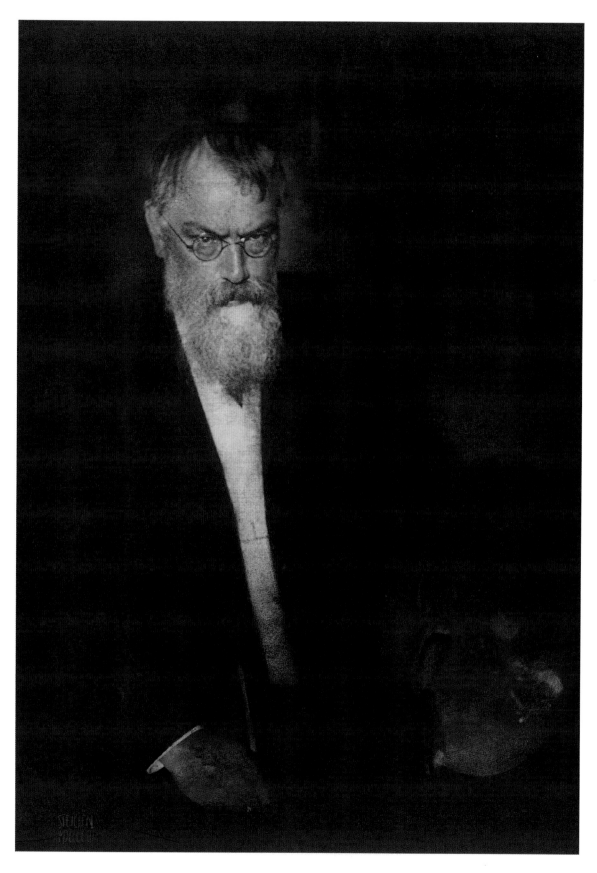

EDWARD J. STEICHEN ■ *Portrait—Franz von Lenbach,* 1901.

Direct carbon, The Metropolitan Museum of Art, The Alfred Stieglitz Collection, 1933.

EDWARD J. STEICHEN ■ *Portrait—Otto Stuck, A French Photographer,* circa 1901.

Direct carbon, The Metropolitan Museum of Art, The Alfred Stieglitz Collection, 1949.

EDWARD J. STEICHEN ■ *The Pool—Evening*, 1899.

Platinum, The Metropolitan Museum of Art, The Alfred Stieglitz Collection, 1949.

EDWARD J. STEICHEN ◼ *Rodin—Le Penseur,* 1901.

Photogravure, courtesy George Eastman House.

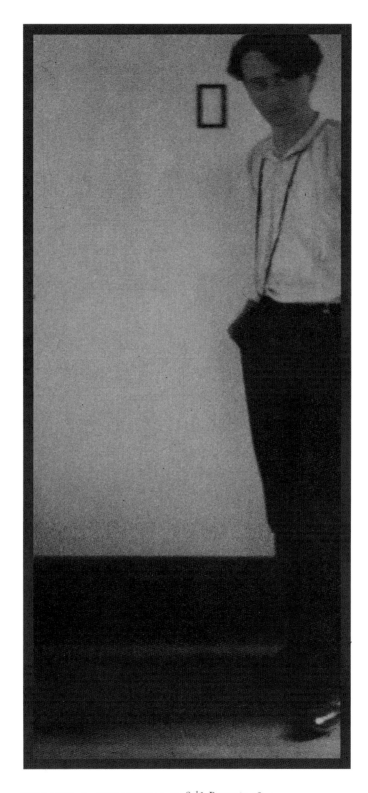

EDWARD J. STEICHEN ■ *Self-Portrait,* 1899.

Platinum, The Metropolitan Museum of Art, The Alfred Stieglitz Collection, 1933.

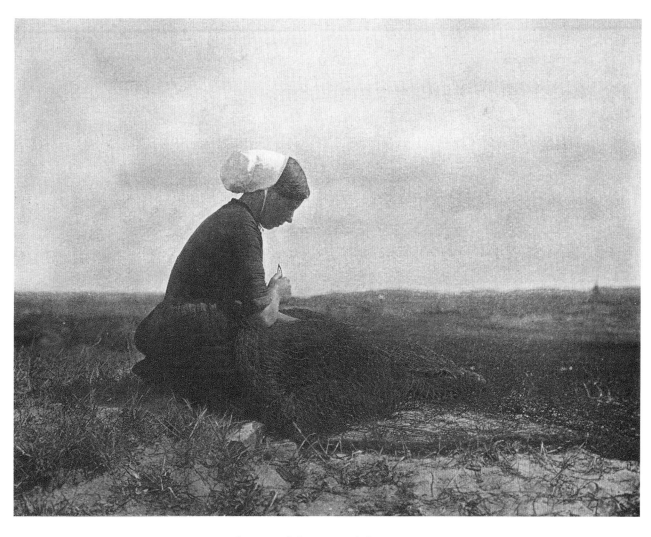

ALFRED STIEGLITZ ■ *Mending Nets (The Net Mender)*, 1894.

Photogravure, courtesy George Eastman House.

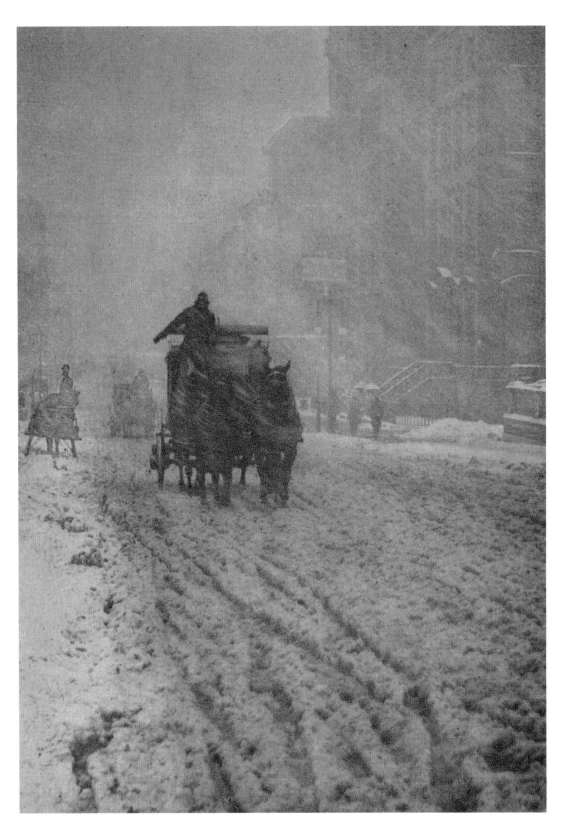

ALFRED STIEGLITZ ■ *Winter—Fifth Avenue,* 1893.

Photogravure, courtesy George Eastman House.

ALFRED STIEGLITZ ◼ *Watching for the Return*, 1894.

Photogravure, Royal Photographic Society, Bath.

ALFRED STIEGLITZ ∎ *Scurrying Home, 1894.*

Photogravure, courtesy George Eastman House.

ALFRED STIEGLITZ ■ *Decorative Panel (On the Seine near Paris)*, 1894.

Photogravure, Collection Center for Creative Photography, The University of Arizona, Tucson.

ALFRED STIEGLITZ ∎ *An Icy Night*, 1898, printed 1920s.

Gelatin silver from a glass negative, The Metropolitan Museum of Art, The Alfred Stieglitz Collection, 1949.

ALFRED STIEGLITZ ■ *September,* 1897 or 1898.

Photogravure, courtesy George Eastman House.

ALFRED STIEGLITZ ■ *Katwyk Beach,* 1894.

From W. I. Lincoln Adams, *Sunlight and Shadow* (New York: The Baker and Taylor Co., 1897).

ALFRED STIEGLITZ ■ *At Anchor,* 1894.

Halftone, courtesy George Eastman House.

ALFRED STIEGLITZ ▪ *Spring,* 1901, printed 1913.

Photogravure, The Metropolitan Museum of Art, The Alfred Stieglitz Collection, 1949.

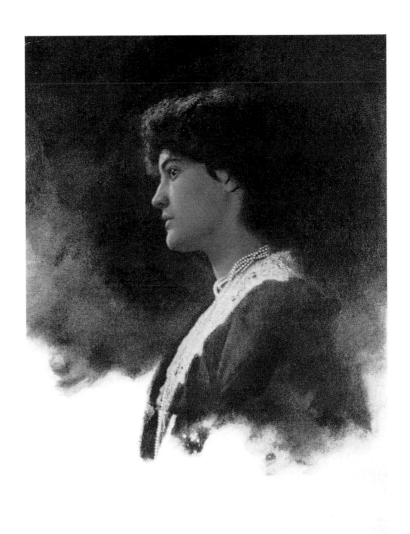

ALFRED STIEGLITZ ■ *Vignette in Oxalate and Mercury, 1898.*

Colored halftone, courtesy George Eastman House.

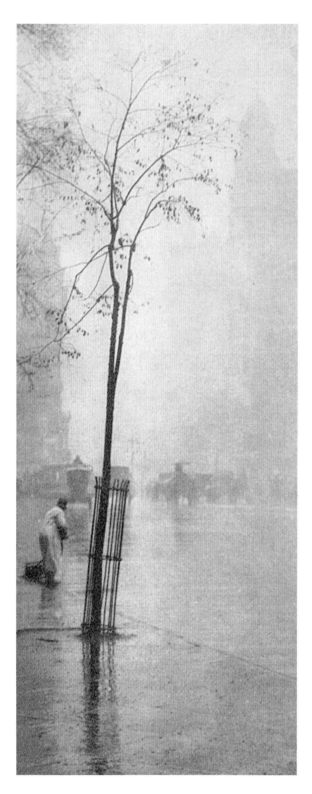

ALFRED STIEGLITZ ■ *Spring Showers,* 1901.

Photogravure, courtesy George Eastman House.

ALFRED STIEGLITZ ■ *Gossip—Venice*, 1894.

Halftone, courtesy George Eastman House.

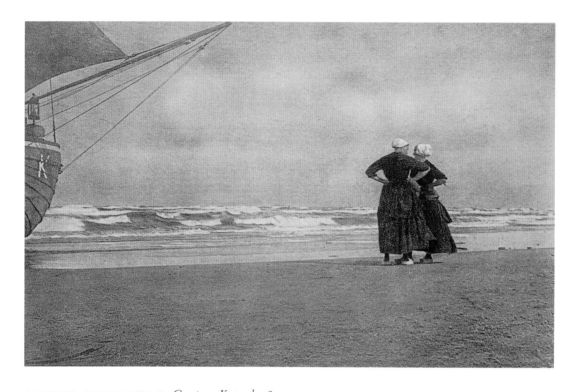

ALFRED STIEGLITZ ■ *Gossip—Katwyk*, 1894.

Photogravure, Collection Center for Creative Photography, The University of Arizona, Tucson.

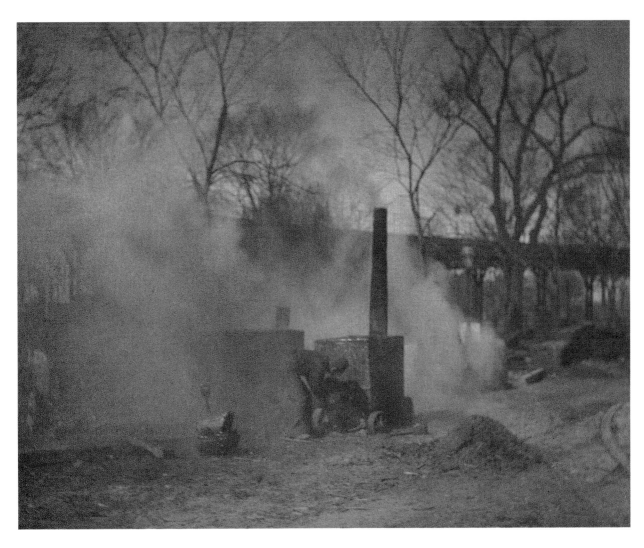

ALFRED STIEGLITZ ■ *The Street Paver,* 1892/1893.

Photogravure, courtesy George Eastman House.

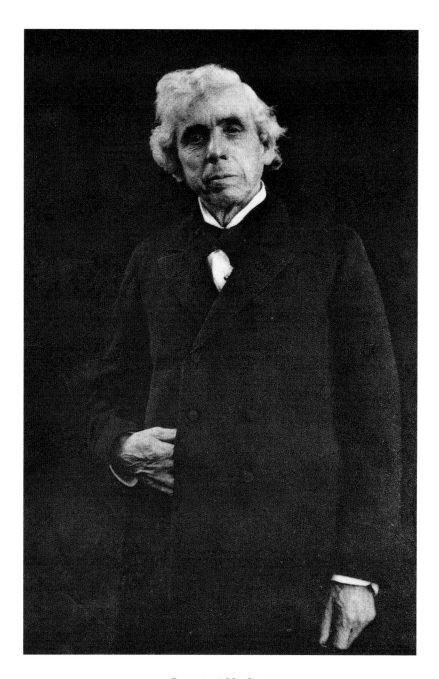

ALFRED STIEGLITZ ■ *Portrait of Mr. R.,* 1895.

Photogravure, courtesy George Eastman House.

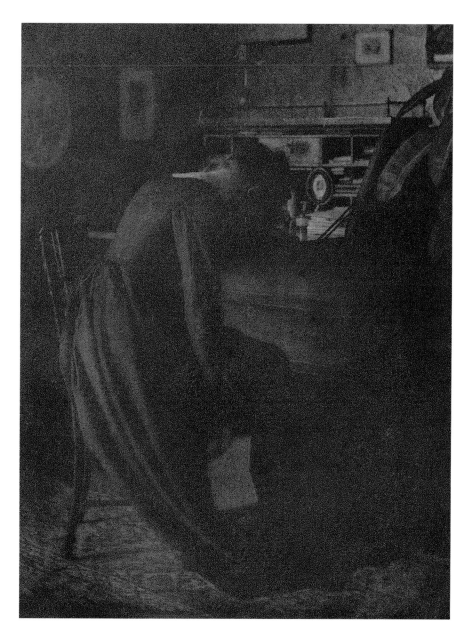

EDMUND STIRLING ■ *Bad News,* circa 1900.

Photogravure, courtesy George Eastman House.

EDMUND STIRLING ■ *Old Wedding Dress,* circa 1899.

Halftone, from *Photo-Beacon,* June 1900, courtesy George Eastman House.

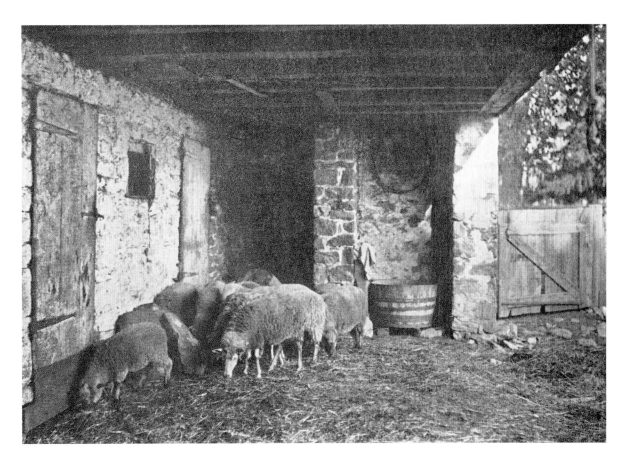

HENRY TROTH ■ *In the Fold,* circa 1900.

Halftone, courtesy George Eastman House.

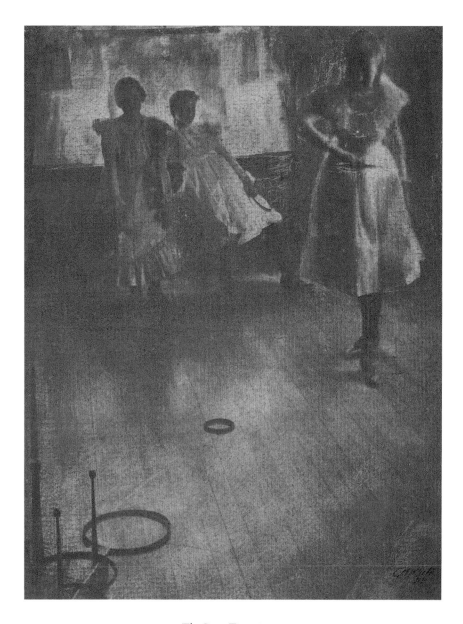

CLARENCE H. WHITE ■ *The Ring Toss*, 1899.

Gum bichromate, The Metropolitan Museum of Art, The Alfred Stieglitz Collection, 1933.

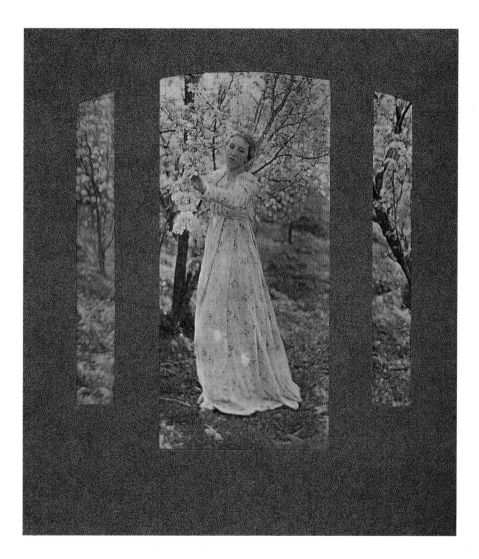

CLARENCE H. WHITE ■ *Spring,* 1898.

Photogravure, courtesy George Eastman House.

CLARENCE H. WHITE ■ *Telegraph Poles*, 1898.

Photogravure, courtesy George Eastman House.

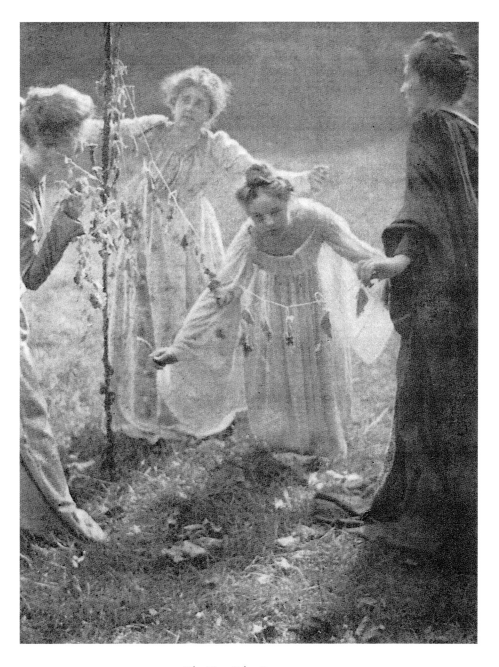

CLARENCE H. WHITE ■ *The May Pole*, 1899.

From Charles H. Caffin, *Photography as a Fine Art* (New York: Doubleday, Page & Co., 1901).

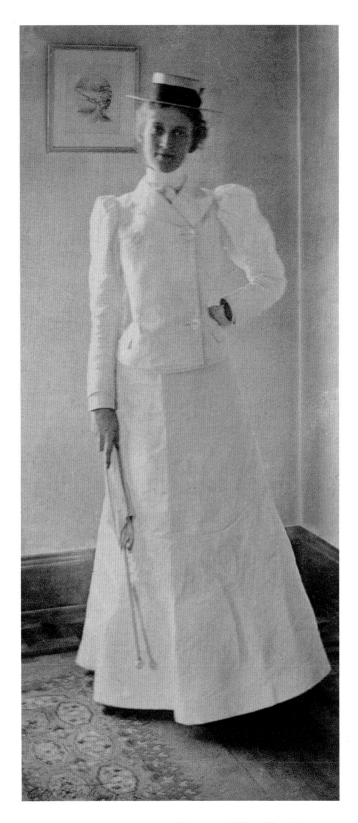

CLARENCE H. WHITE ■ *Portrait of Mrs. H., 1898.*

Platinum, The Metropolitan Museum of Art, The Alfred Stieglitz Collection, 1933.

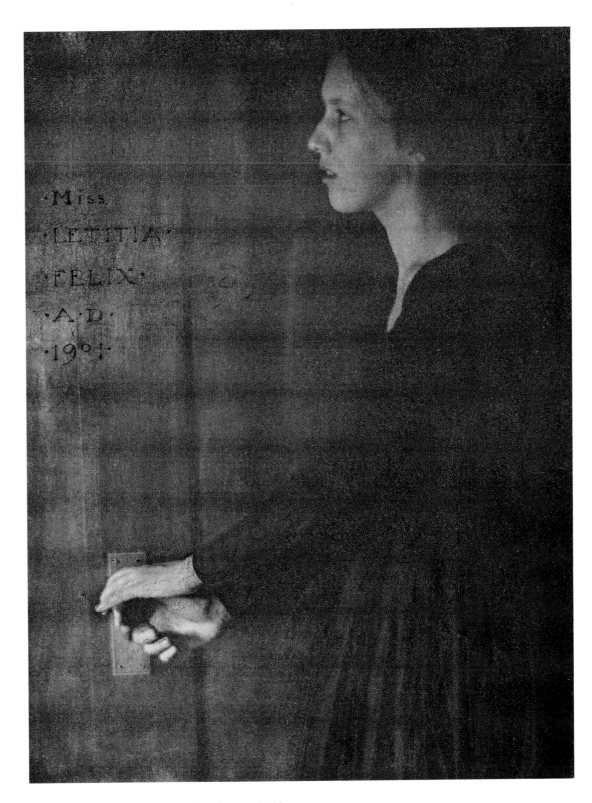

CLARENCE H. WHITE ■ *Miss Letitia A. Felix,* 1901.

Platinum, The Metropolitan Museum of Art, The Alfred Stieglitz Collection, 1933.

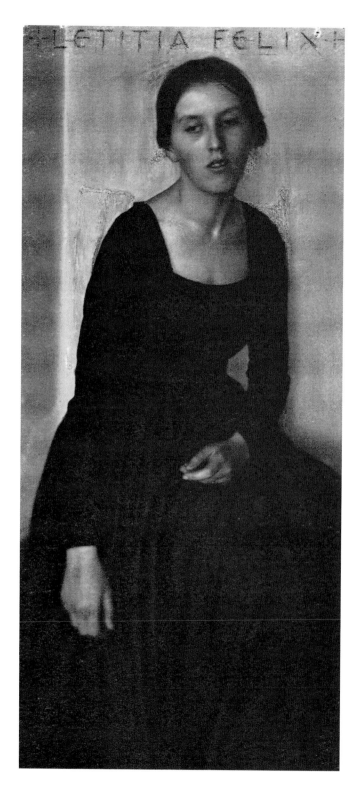

CLARENCE H. WHITE ■ *Portrait—Letitia Felix,* 1897.

Platinum, The Metropolitan Museum of Art, The Alfred Stieglitz Collection, 1933.

Biographies of the Photographers

The photographers whose names are preceded by an asterisk are not represented by images in the reconstructed 1902 exhibition, as their photographs could not be identified.

C. YARNALL ABBOTT ■ 1870–1938

Based in Philadelphia and Massachusetts, C. Yarnall Abbott was a lawyer, painter, teacher, lecturer, and writer in addition to being a photographer. He began making photographs in 1898 and within a year was exhibiting in the Philadelphia Photographic Salons. The following year, Abbott had a one-man exhibition that was shown in Philadelphia and Boston. He was a member of the Photographic Society of Philadelphia and of London's selective Linked Ring. Although included in the first Photo-Secession exhibition, he did not become a member of the group; yet his work did appear in *Camera Notes* and later in *Camera Work*. Abbott's prints were mainly gum bichromate and glycerine-developed platinum prints, a process he reportedly pioneered. Abbott turned his artistic talents to painting after about 1916.

PRESCOTT ADAMSON ■ No dates

Born in Germantown, Pennsylvania, Prescott Adamson lived in Philadelphia. He exhibited in the photographic salons of Philadelphia, Chicago, and London and was a member of the Photographic Society of Philadelphia, where he also lectured.

ARTHUR E. BECHER ■ 1877–1960

Originally from Freiburg, Germany, Arthur Becher studied art in both Germany and the United States. He was a book and magazine illustrator as well as a photographer. Although his work was included in the 1902 show, he was not a member of the Photo-Secession.

CHARLES I. BERG ■ 1856–1926

A founding member of the Camera Club of New York, Berg was trained as an architect in London and Paris and began practicing in 1880. He took up photography in the late 1880s. As the first chairman of the Camera Club's print committee, Berg oversaw the club's series of one-person shows, including his own in 1900. Stieglitz published five of his photographs in *Camera Notes*. Berg was not a member of the Photo-Secession.

*ALICE BOUGHTON ■ 1866–1943

Born and raised in Brooklyn, Alice Boughton studied painting in Paris and Rome. A protégée of Gertrude Käsebier, she opened her own photographic portrait studio in New York, which she maintained for over forty years, until her retirement in 1931. Printed mainly in platinum, her body of work consisted largely of portraiture, which included prominent literary and theatrical figures, as well as allegorical subjects.

JOHN G. BULLOCK ■ 1854–1939

John G. Bullock was initially trained as a pharmacist and worked at a drug and chemical firm. In 1882 he began to take photographs. That same year he became a member of the Photographic Society of Philadelphia, of which he later became president. Bullock was one of Stieglitz's early associates. In 1891 he became one of the first Americans to have his prints exhibited in Europe. Bullock was one of the thirteen founding members of the Photo-Secession.

ROSE (HARRIET CANDACE) CLARK ■ 1852–1942
ELIZABETH FLINT WADE ■ ?–1915

From 1898 to 1910 Rose Clark and Elizabeth Flint Wade, based in Buffalo, New York, worked collaboratively on their photographs. In 1900 Clark and Wade had a joint solo exhibition at the Camera Club of New York. Two years later, they contributed to the Photo-Secession exhibition, although they never became members of the group. It has been suggested that Clark handled the creative aspects while Wade dealt with the technical components of their photographs. However, both women had their own one-woman shows. From 1901 to 1912 Wade contributed a monthly column to *Photo Era*, during which time she also served as an associate editor.

F. COLBURN CLARKE ■ No dates

An illustrator as well as a photographer, F. Colburn Clarke never belonged to the Photo-Secession. He was a member of the Camera Club of New York, and his work was included in the club's annual members' exhibitions at the turn of the century. His images were also reproduced in *Camera Notes* under the name of Frederick C. Clarke.

F. HOLLAND DAY ■ 1864–1933

F. Holland Day began taking photographs in 1887, four years after setting up a publishing house, Copeland and Day, with Harvard professor Herbert Copeland. In 1895 George Davison, a photographer and a founder of London's Linked Ring, discovered Day, and in 1896 Day became one of the first Americans elected to the Linked Ring. Independently wealthy, he had the means to travel and promote the cause of photography both in America and in Europe. He is noted for taking the work of American pictorialists to Europe, and exhibiting the photographs in London and Paris under the name the New School of American Photography in 1900–01. Day and Stieglitz were rivals who both fought for the recognition of American pictorial photography. Although Day's prints were included in the Photo-Secession exhibit of 1902, he refused an invitation to join the Photo-Secession. Later, Day would also decline Stieglitz's request to publish his images in *Camera Work*. Stieglitz exhibited Day's work from his personal collection of photographs, without Day's permission.

MARY M. DEVENS ■ Circa 1857–1920

Mary M. Devens's photographic debut took place in 1898 when her work was shown at the first Philadelphia Salon. Two years later, F. Holland Day took a number of her works, along with the photographs of other American pictorialists, to Europe, where they traveled from London to Paris as part of Day's New School of American Photography exhibition. Devens also contributed images to *Camera Work*.

WILLIAM B. DYER ■ 1860–1931

William B. Dyer first took up photography as a hobby around 1895 before becoming a commercial photographer in 1897. A founding member of the Photo-Secession, Dyer had shown his work at Clarence White's Newark, Ohio, exhibition in 1900 and organized the Chicago Photographic Salon in that year. In 1902 Dyer was elected to the Linked Ring. Little remains of his work because of a 1915 fire that destroyed his Hood River, Oregon, home.

*THOMAS M. EDMISTON ■ No dates

Thomas M. Edmiston was a member of Clarence White's Newark (Ohio) Camera Club, which the latter founded in 1898. Edmiston also participated in White's Newark exhibition of 1900. He was considered a member of the "White School," an informal label given to those Ohio photographers who were influenced by White and his work. Edmiston was not a member of the Photo-Secession.

FRANK EUGENE ■ 1865–1936

Frank Eugene was born in New York City and later attended the City College of New York. In 1886 he went to Germany to study at the Royal Bavarian Academy of Fine Arts in Munich. Eugene initially trained to be a painter; he took up photography as a hobby, but soon developed into a professional. A founding member of the Photo-Secession, Eugene saw his prints first shown at the Camera Club in 1899. The following year he was elected to the Linked Ring. His work was published in both *Camera Notes* and *Camera Work*. Eugene was widely respected not only as a photographer but also as a teacher of photography. He lived in Germany permanently from 1906. In 1913 he was appointed Royal Professor of Pictorial Photography by the Royal Academy of the Graphic Arts at Leipzig; it was the first academic recognition of this kind for photography anywhere in the world.

DALLETT FUGUET ■ 1868–1933

Born and raised in Philadelphia, Dallett Fuguet attended the University of Pennsylvania. In 1889 he moved to New York, where he joined the Camera Club and began working with Stieglitz on *Camera Notes*. He contributed articles and poetry to the publication and edited and proofed others' work. Although he did not exhibit often, his work was included in the Chicago and Philadelphia salons. Fuguet quit his position at *Camera Notes* when Stieglitz left the magazine in 1902. Although he was a founding member of the Photo-Secession, he did not exhibit with them again. Fuguet served as associate editor for Stieglitz's *Camera Work* throughout its existence. He also contributed essays and poems to the magazine.

*TOM HARRIS ■ No dates

Although Tom Harris was included in the 1902 Photo-Secession exhibition, he was not a member of the Photo-Secession. Little is known about his life and none of his images appears to be extant.

GERTRUDE KÄSEBIER ■ 1852–1934

Gertrude Käsebier was born in Des Moines, Iowa, and spent her early years in Colorado. In 1889 she lived in Brooklyn, New York, where she studied at the Pratt Institute. Four years later, she went to Germany, where she apprenticed herself to a German chemist, learning the technical side of photography. In 1897 Käsebier began working at a commercial portrait studio in Brooklyn; later that year she established her own portrait business in New York. In addition to professional portraiture, Käsebier made pictorial photographs. Her work was shown in numerous exhibitions, including the Philadelphia Photographic Salon of 1898. Two years later, she became the first woman elected to the Linked Ring and in an exhibition catalogue was referred to as "the foremost professional photographer in the United States." Although Käsebier was a founding member of the Photo-Secession, she was often at odds with Stieglitz and resigned from the group in 1912. She cofounded the Pictorial Photographers of America, along with Alvin Langdon Coburn and Clarence H. White, in 1915.

JOSEPH T. KEILEY ■ 1869–1914

Joseph Keiley was a Wall Street lawyer by profession. He joined the Camera Club of New York in 1899 and began to sit on the prints-and-publications committee of the club. In 1900 Keiley became the fourth American to be elected to the Linked Ring. That year, the July issue of *Camera Notes*, of which he was an associate editor, was devoted to his images. Two years later, however, Keiley, along with Stieglitz, resigned from *Camera Notes*. They both went on to *Camera Work*, where Keiley once again held the position of associate editor. A founding member of the Photo-Secession, Keiley suggested "an American Linked Ring," one of the ideas leading to the Photo-Secession. He was also the historian of the Photo-Secession and was instrumental in hanging the National Arts Club exhibition.

*MARY MORGAN KEIPP ■ 1875–1960

Born in Selma, Alabama, Keipp was trained as a nurse anesthetist. She worked for a brief time in New York City before returning to the South. Although she showed one image in the 1902 Photo-Secession show and contributed to other exhibitions around this time, she did not become a member of the group.

OSCAR MAURER ■ 1871–1965

Oscar Maurer was born in New York City. He moved to California to attend the University of California at Berkeley, where he studied chemistry and physics. In 1900 Maurer participated in his first national exhibition, showing *The Storm* at the Chicago Photographic Salon. In July 1902 this frequently reproduced image appeared in *Camera Notes*. Maurer became a noted pictorialist of the San Francisco Bay Area. One of the few West Coast photographers in Stieglitz's Photo-Secession, he showed two of his images in the 1902 exhibit. However, Maurer's prints were not included in any further Photo-Secession shows. Maurer opened a studio in Berkeley after his San Francisco studio was consumed by fire after the earthquake of 1906.

WILLIAM B. POST ■ 1857–1925

William B. Post was already established as a pictorial photographer by the early 1890s when Stieglitz published his work in *The American Amateur Photographer* (the first photography publication Stieglitz worked on). Post, who had been a member of the Society of Amateur Photographers, New York, since 1889, was the one who first introduced Stieglitz to the hand camera, in 1892. Stieglitz's next publication, *Camera Notes*, also included Post's photographs.

Post's work was included in numerous shows at the Camera Club and in the International Exhibition of Pictorial Photography of 1910 in Buffalo, organized by Alfred Stieglitz on behalf of the Photo-Secession. Advised by Stieglitz, Post began collecting European and American masterpieces of pictorial photography in 1898.

ROBERT S. REDFIELD ■ 1849–1923

A Philadelphia native, Robert Redfield was director of the Sixth Annual Joint Exhibition in Philadelphia, held in 1893 (sponsored jointly by the Boston Camera Club, the Photographic Society of Philadelphia, and the Society of Amateur Photographers of New York), the first major international photography exhibition in America. As president of the Philadelphia Photographic Society, he helped organize the Philadelphia Photographic Salons from 1898 to 1900. By 1901, Redfield and other pictorialists resigned from the society, as it was taken over by members of the Rational, or Old, School of photography, who preferred scientific, documentary images over purely artistic efforts. A founding member of the Photo-Secession, Redfield was also included in Clarence White's Newark, Ohio, exhibit of 1900.

W. W. (WILLIAM WHETTEN) RENWICK ■ 1864–1933

An architect, sculptor, and painter in addition to being a photographer, W. W. Renwick specialized in ecclesiastical architecture and design. Renwick was not a member of the Photo-Secession.

EVA LAWRENCE WATSON-SCHÜTZE ■ 1867–1935

At the age of sixteen, Watson-Schütze was enrolled in the Pennsylvania Academy of the Fine Arts in Philadelphia, where she studied under Thomas Eakins. In 1897 she opened her own studio in Philadelphia; the following year her work was included in the first Philadelphia Photographic Salon. In 1901, after marrying University of Chicago professor Martin Schütze, Watson-Schütze reestablished her studio in Chicago. Already a member of the Linked Ring, she became a founding member of the Photo-Secession in 1902. She contributed both images and articles to Stieglitz's *Camera Work.*

*T. O'CONOR SLOANE, JR. ■ 1851–1940

Born in New York, T. O'Conor Sloane was not only a pictorial photographer but also a noted scientist. He was a professor of natural sciences at Seton Hall College in South Orange, New Jersey, an inventor, and an author.

EMA SPENCER ■ 1857–1941

A founding member of Clarence White's Newark, Ohio, Camera Club, Ema Spencer participated in the Newark exhibit of 1900. A professional portrait photographer in Newark, Spencer shared a studio with White and belonged to the so-called White School.

EDWARD J. STEICHEN ■ 1879–1973

Steichen was apprenticed at age fifteen to a commercial designer in Milwaukee, Wisconsin. During his four-year term, he took his first photographs and, in the late 1890s, organized and became the first president of the Milwaukee Art Students' League. In 1900, after his work was shown at the Chicago Salon, Steichen was brought to the attention of Alfred Stieglitz through Clarence White. The following year he went off to Paris, where his photographs were included in F. Holland Day's New School of American Photography. That same year, Steichen declined an invitation to join the Linked Ring. Upon his return from Paris, in 1902, Steichen took up residency at 291 Fifth Avenue, which would become the home of the Little Galleries of the Photo-Secession in 1905. Steichen was an official cofounder, member of the governing board, and fellow of the Photo-Secession. He worked as a photographer and a painter, and also organized a number of influential exhibitions at the 291 gallery, including the first one-man exhibitions in America of Matisse and Cézanne. Steichen experimented with color photography and different, highly complex methods of developing his prints. He later worked in fashion, advertising, and portraiture, his photographs appearing in such publications as *Vogue* and *Vanity Fair.* Steichen also headed departments of aviation and naval photography for the U.S. government during World War II. From 1947 to 1962 he was director of the department of photography for the Museum of Modern Art, where he curated the famed Family of Man exhibition of 1965 and numerous others.

ALFRED STIEGLITZ ■ 1864–1946

Alfred Stieglitz, photographer, author, editor, collector, and gallery proprietor, was the reason and the cause behind the Photo-Secession. Born in Hoboken, New Jersey, Stieglitz was sent to Germany for his studies in 1881. At the Technische Hochschule in Berlin, Stieglitz initially studied mechanical engineering before transferring to photo-

chemistry. In 1883 he bought his first camera and actively photographed from that point onward. In 1894 he became the first American admitted into the Linked Ring. After he returned to America in 1890, Stieglitz worked for five years in the photoengraving business in New York City while writing for *The American Amateur Photographer*, which he later edited. In 1897 he founded *Camera Notes*, of which he was also the editor, before leaving it in 1902 to start *Camera Work*, the mouthpiece of the Photo-Secession. Between 1905 and 1917 he operated the Little Galleries of the Photo-Secession (291), showing both photographs and modernist art by European and American artists. Most of Stieglitz's photographic work is characterized by a straight, unmanipulated style. He experimented with various development processes and techniques. After a long career, Stieglitz stopped making photographs in 1937. Through his organizations, publications, exhibitions, and personal encouragement Stieglitz championed the cause of photography as an art and, along with colleagues such as Clarence White and Edward Steichen, and his rival, F. Holland Day, legitimized the medium as an art.

EDMUND STIRLING ■ 1861–1948

Stirling served as a reporter, editor, and writer for the *Philadelphia Public Ledger*. His photography was first exhibited in 1888 at the second Joint Exhibition and at the Photographic Society of Philadelphia's Members' Exhibition. Stirling served as secretary of the Photographic Society of Philadelphia for seven years, editing its journal and helping to organize three of its photographic salons. In 1902 he became a member of the Linked Ring and a founding member of the Photo-Secession.

HENRY TROTH ■ 1860–1945

A professional photographer and Philadelphia native, Henry Troth was introduced to pictorial photography by way of his interest in botany. A member of the Philadelphia Botanical Society from 1897 to 1902, Troth often focused his documentary-style images on botanical subjects. In 1898 he participated in the First Annual International Salon and Exhibition of the Pittsburgh Amateur Photographers' Society and the first Philadelphia Photographic Salon. Through that salon, Troth became acquainted with pictorial photographers such as Gertrude Käsebier, Clarence White, and F. Holland Day and soon fell under their influence. Although included in the 1902 exhibition, he was not a Photo-Secessionist.

*MATHILDE WEIL ■ 1872–1918?

Weil studied art in Philadelphia at the Decorative Art League, the Pennsylvania Academy of the Fine Arts, the Museum School of Industrial Art, and privately. She was a member of the Philadelphia Photographic Society. She established a portrait studio and was considered one of the foremost women photographers of her time. She was not a member of the Photo-Secession.

CLARENCE H. WHITE ■ 1871–1925

Originally from Newark, Ohio, White was a self-taught photographer. He took up photography around 1893. Just a few years later he won a gold medal from the Ohio Photographers' Association, and in 1898 he helped found the Camera Club of Newark, Ohio. Alfred Stieglitz discovered White at the 1898 Philadelphia Salon and arranged a solo exhibition for him at the Camera Club of New York in 1900. Later that year, F. Holland Day also held a one-man show of White's work at the Boston Camera Club and included White's photographs in his New School of American Photography exhibition. White was a founding member of the Photo-Secession and a member of the Linked Ring. He taught at Teachers College of Columbia University and at the Brooklyn Institute of Arts and Sciences, and in 1914 founded the Clarence White School of Photography in New York. The following year he helped establish the Pictorial Photographers of America, serving as its first president.